The LAZY FRENCHIE

in NYC

lifestyle guide for instagram lovers

Aurélie Hagen

 LANNOO

CONTENTS

Manhattan

WEST HARLEM

 67
123
Columbia University
116th St & Broadway
@columbia

 57
Settepani
196 Malcolm X Blvd
@settepaninyc

Double Dutch Espresso
2194 Frederick Douglass Blvd
@doubledutchespresso **61**

 159
Cafeine
2124 Frederick Douglass Blvd
@cafeineharlem

EAST HARLEM

 48
UGC eats
1674 Park Ave
@ugceats

 134
Frenchy Coffee
129E E 102nd St
@frenchycoffeenyc

 53
Museum of the city of NYC
1220 5th Ave & 103rd Street
@museumofcityny

UPPER WEST SIDE

Hearst Plaza at Lincoln Center
30 Lincoln center plaza
@LincolnCenter **95**

 95
Metropolitan Opera
30 Lincoln Center Plaza

 69
Marlow Bistro
1018 Amsterdam Ave
@marlowbistro

Irving Farm Coffee
224 W 79th St
@Irvingfarm **55**

 113
Recolte
1745, 300 Amsterdam Ave
@therecolte

UPPER EAST SIDE

93
177
Central Park
@CentralParkNYC

83
Bareburger
1681 1st Avenue
@bareburger

Pizza Beach
1426 3rd Ave at 81st Street
@pizzabeach **47**

165
Blake Lane
1429 3rd Ave
@blakelanenyc

191
Hutch and Waldo
247 E 81st St
@hutchandwaldo

137
The UES NYC
1707 2nd Ave
@theuesnyc

138
Urban Outfitters
1511 3rd Ave
@urbanoutfitters

49
Anthropologie
1230 3rd Ave
@anthropologienyc

72
Albertine Books
972 5th Ave
@albertinebooks

MIDTOWN WEST

55
Bryant Park
@bryantparknyc

41
Bluestone Lane
55 Greenwich Ave
@bluestonelane

Beyond Sushi
62 W 56th St
@beyondsushinyc **47**

109
Petrossian
911 7th Ave
@petrossiannyc

Wafels and Dinges
6th Ave and W 42nd St
@wafelsanddinges **127**

55
Southwest Porch
41 W 40th St (in Bryant Park)
@SouthwestPorchNYC

97
Bibble and Sip
253 W 51 St
@bibbleandsip

177
Hyatt Herald Square
30 W 31st St
@hyatths

167
Muji
620 8th Ave
@mujiusa

MIDTOWN EAST

 129 Urban Space
East 45th &, Vanderbilt Ave
@urbanspacenyc

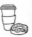 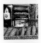 **139** Bien Cuit
89 E 42nd St
@biencuitnyc

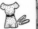 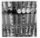 **111** Swatch Store
87E 42nd St
@swatch_us

HELL'S KITCHEN

 50 Hummus Kitchen
768 9th Ave
@hummuskitchen9thave

 84 Annex Markets
408-424 W 39th St
@annexmarkets

CHELSEA

Flower District
W 28th St between Broadway
and 7th Ave **45** **91** Pier 62
61 Chelsea Piers
@HudsonRiverPark

 87 Meatball shop
200 9th Ave
@meatballers

Gansevoort market
353 W 14th St
@gansevoortmarketnyc **95** **99** Som Bo
143 8th Ave
@sombofood

Pastai
186 9th Ave
@pastainyc **118** **137** Citizens of Chelsea
401 W 25th St
@citizensofchelsea

Hanamizuki
143 W 29th St
@hanamizukicafe **157** **35** Eleni's Cookies
250 7th Ave
@elenisny

129 The Donut Pub
203 W 14th St
@donut.pub

MomenTea
64 7th Ave
@MomenTeaOfficial **149** 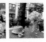 **191** Jue Lan Club
49 W 20th St
@juelanclub

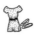
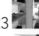

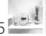
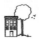 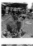
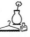 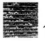
AROUND UNION SQUARE

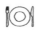
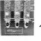
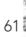

AROUND FLATIRON DISTRICT

82
164
Club Monaco
160 5th Ave
@ clubmonaco

Bandier
108 5th Ave
@ bandier **139** **150**
Tory Sport
129 5th Ave
@ torysport

Madewell
115 5th Ave
@ madewell **123** **199**
Lou & Grey
138 5th Ave
@ louandgrey

 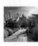 **34**
Fishs Eddy
889 Broadway
@ fishseddynyc

Lego Store
620 5th Ave
@ lego **129** **153**
Marimekko
200 5th Ave
@ marimekko

MEATPACKING DISTRICT

127
195
Highline
@ highlinenyc

Santina
820 Washington St
@ santinanyc **124** **178**
The Wild Son
53 Little W 12th St
@ thewildsonnyc

 70
Whitney Museum
99 Gansevoort St
@ whitneymuseum

WEST VILLAGE

Rosemary's
18 Greenwich Ave
@ rosemarysnyc **145** **113**
While We Were Young
183 W 10th St
@ whilewewereyoungnyc

Broken Coconut
15 E 4th St
@ brokencoconut **162** **193**
Baby Brasa
173 7th Ave S
@ babybrasa

The Upper Rust
143 7th Ave S
@ TheUpperRust **91** **103**
The Meadow
523 Hudson St
@ atthemeadow

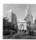

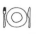 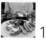

Spark Pretty
333 East 9th St
169 @sparkpretty

Sunrise Mart
4 Stuyvesant St, 2nd Floor
@sunrise_mart **133**

John Derian
6 East Second Street
133 @johnderian

Pink Olive
439 East 9th St
@pinkolive **181**

Crystals Garden
247 E 10th St
105 @crystalsgarden

Flower Power
406 E 9th St
@flowerpower_nyc **105**

Anme Shop
328 E 9th Street
183 @anmeshop

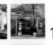
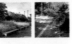

Codex
1 Bleecker St
39 @codexbooks

ALPHABET CITY

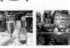
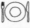

Tompkins Square Park
@TompkinsSquarePark
41

9th St Community Garden
9th St. and Ave. C
@9th_and_c **59**

Creative Little Garden
530 E 6th St
149 @GrowNYC

East River Park
FDR Drive
@EastRiverPark **195**

Los Amigos Garden
221E 3rd St
140

Pardon My French
103 Ave B
@pmf_nyc **57**

Home Cooking NY
158 Grand St
189 @homecookingny

SOHO

Pi Bakerie
512 Broome St
97 @pibakerie

La Esquina
114 Kenmare
@esquinanyc **129**

Dig Inn
70 Prince St
169 @diginn

Jack's Wife Freda
224 Lafayette St
@jackswifefreda **175**

Banter
169 Sullivan St
187 @banter_nyc

NOLITA

CHINATOWN

TRIBECA

LOWER EAST SIDE

Sauce
78 Rivington St
@saucerestaurant **103**

125 Una pizza Napoletana
175 Orchard St
@unapizzanapoletana

Jajaja **160**
162 E Broadway
@jajajanyc **161**
184 Freemans
Freeman Alley
@freemansrestaurant

Supermoon
120 Rivington St
@supermoonbakehouse **155**

101 Chill house
149 Essex St.
@chillhouse

El Rey
100 Stanton St
@elreynyc **173**
125 Erin McKenna's Bakery
248 Broome St
@erinmckennasbakery

185 Morgenstern's Ice cream
2 Rivington St
@morgensternsnyc

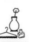
105 Jadis
42 Rivington St
@jadiswinebar

The Rising States
168 Ludlow St
@therisingstates **100**

128 Reformation
156 Ludlow St
@reformation

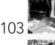

Top Hat
245 Broome St
@tophatnyc **103**
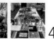
115 Tictail Market
90 Orchard St
@tictail

Green Fingers Market
5 Rivington St
@greenfingersmarket **171**
49 CW Pencil Enterprise
15 Orchard St
@cwpencilenterprise

SEAPORT DISTRICT

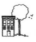

189 Pier 15
South and Fletcher Sts

151 Fulton Stall Market
91 S St
@fultonstallmarket

 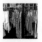
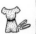 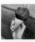
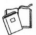

FINANCIAL DISTRICT

Brooklyn

GREENPOINT

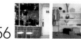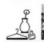
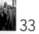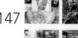
WILLIAMSBURG

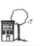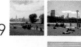
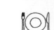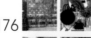

Diviera Alimentari
131 Berry St
@diviera_alimentari_nyc
77

Diviera Drive
131 Berry St
@diviera_drive_nyc
155

Little Choc Apothecary
141 Havemeyer St
@little_choc
85

Rosarito
168 Wythe Ave
@rosaritofish
94

Ovenly
43 N 5th St
@ovenly
95

Sunday
348 Wythe Ave
@sundayinbrooklyn
121

Bakeri
150 Wythe Ave
@bakeribrooklyn
159

Le Labo Café of Williamsburg
120 N 6th St
@lelabofragrances
69

Loosie Rouge
91 S 6th St
@loosierouge
167

Gelateria Gentile
253 Wythe Ave
@gelateria_gentile_ny
175

Wythe Hotel
80 Wythe Ave
@wythehotel
33

Surfbar
139 N 6th St
@surfbarbrooklyn
65

BK Brewery
79 N 11th St
@brooklynbrewery
127

Grassroots Juicery
336a Graham Ave
@grassrootsjuicery
154

Awoke Vintage
132 N 5th St
@awokevintagebrooklyn
90

Le Grand Strip
197 Grand St
@legrandstrip
79

Baggu
242 Wythe Ave #4
@baggu
111

Pilgrim Surf Shop
68 N 3rd St
@pilgrimsurfsupply
111

Beacon's Closet
74 Guernsey St
@beaconscloset
145

Red Pearl
200 Bedford Ave
53

Eclectic Collectibles and Antiques
285 Metropolitan Ave
@eclectic_collectiblesny
67

Junk Brooklyn
567 Driggs Ave
@junkbrooklyn
76

Artists and Fleas
70 N 7th St
@artistsandfleas
93

Upstate Stock
2 Berry St
@upstatestock
93

Heatonist
121 Wythe Ave
@heatonist
93

Rituals
143 Berry St
@ritualsusa
126

Meme Antenna
218 Bedford Ave
@memeantenna
153

BUSHWICK

FORT GREENE

Brooklyn Flea
241 37th St
33 @bkflea

Greenlight Bookstore
686 Fulton St
119 @greenlightbklyn

GOWANUS

Ample Hills Creamery
305 Nevins St
51 @amplehills

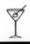 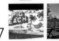

Pig Beach
480 Union St
@pigbeachnyc 57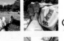
Lavender Lake
383 Carroll St
187 @lavenderlakebrooklyn

PARK SLOPE

Prospect Park
@prospect_park 153 97
Green Space on President Street
222 5th Ave
@GrowNYC

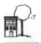
Bricolage
162 5th Ave
75 @bricolagebk

Gather
341 7th Ave 199
Wasan
440 Bergen St
33 @WasanBrooklyn

Du Jour Bakery
365 5th Ave
131 @dujourbakery

Konditori
240 7th Ave
@konditori 75
Gorilla Coffee
472 Bergen St
141 @gorillacoffee

Albero Dei Gelati
341 5th Ave
89 @alberonyc

Union Hall
702 Union St
197 @unionhallny

Brooklyn industry
328 7th Ave
33 @brooklynindustries

 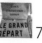
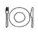 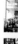 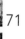

Wanderlustre
419 Court St
175 @wanderlustredesign

CROWN HEIGHTS

Brooklyn Botanic Garden
990 Washington Ave
52 @brooklynbotanic

PROSPECT HEIGHTS

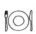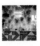
Brooklyn Larder
228 Flatbush Ave
131 @bklynlarder

SUNSET PARK

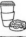
Avocaderia
238 36th St
149 @avocaderia

Extraction Lab
51 35th St
@extractionlab **45** 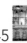 **73**
One Girl Cookies
254 36th St Suite 106
@onegirlcookies

Wanted Design
220 36th St
114 @wanteddesign

Queens

LONG ISLAND CITY

Pantry Market Eatery
24-20 Jackson Ave
119 @pantrymarketeatery

LIC Book Culture
26-09 Jackson Ave
145 @bookculturelic

STREET ART

MAPS

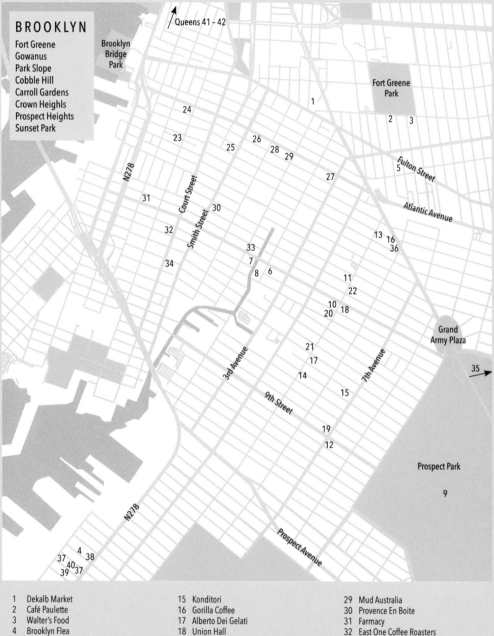

BROOKLYN

Fort Greene
Gowanus
Park Slope
Cobble Hill
Carroll Gardens
Crown Heighls
Prospect Heights
Sunset Park

Queens 41 – 42

Brooklyn Bridge Park

Fort Greene Park

1

2 3

Fulton Street

5

Atlantic Avenue

24

23

26

25

28 29

27

N278

Court Street

31

30

32

Smith Street

33

34

7

8 6

13

16

36

11

22

10

20

18

Grand Army Plaza

35

21

17

14

3rd Avenue

9th Street

7th Avenue

15

19

12

Prospect Park

9

N278

Prospect Avenue

37 4 38
40
39 37

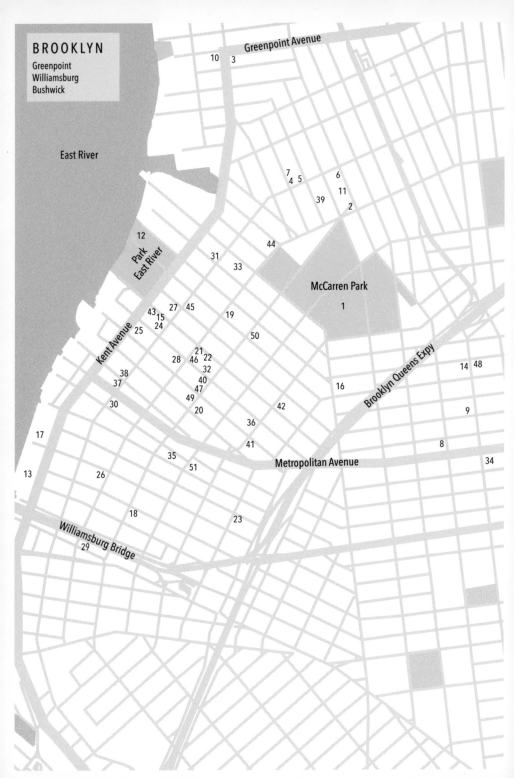

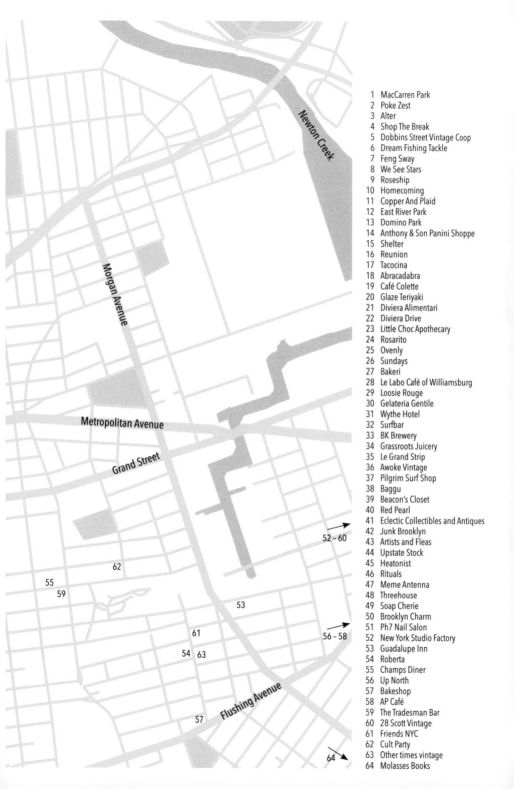

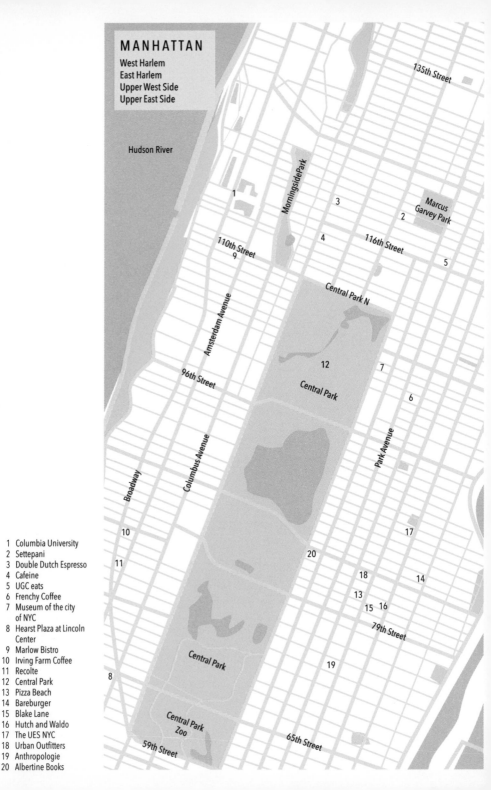

MANHATTAN

West Harlem
East Harlem
Upper West Side
Upper East Side

Hudson River

135th Street

MorningsidePark

Marcus
Garvey Park

116th Street

110th Street

Central Park N

Amsterdam Avenue

96th Street

Central Park

Columbus Avenue

Park Avenue

Broadway

79th Street

Central Park

Central Park
Zoo

65th Street

59th Street

1 Columbia University
2 Settepani
3 Double Dutch Espresso
4 Cafeine
5 UGC eats
6 Frenchy Coffee
7 Museum of the city
 of NYC
8 Hearst Plaza at Lincoln
 Center
9 Marlow Bistro
10 Irving Farm Coffee
11 Recolte
12 Central Park
13 Pizza Beach
14 Bareburger
15 Blake Lane
16 Hutch and Waldo
17 The UES NYC
18 Urban Outfitters
19 Anthropologie
20 Albertine Books

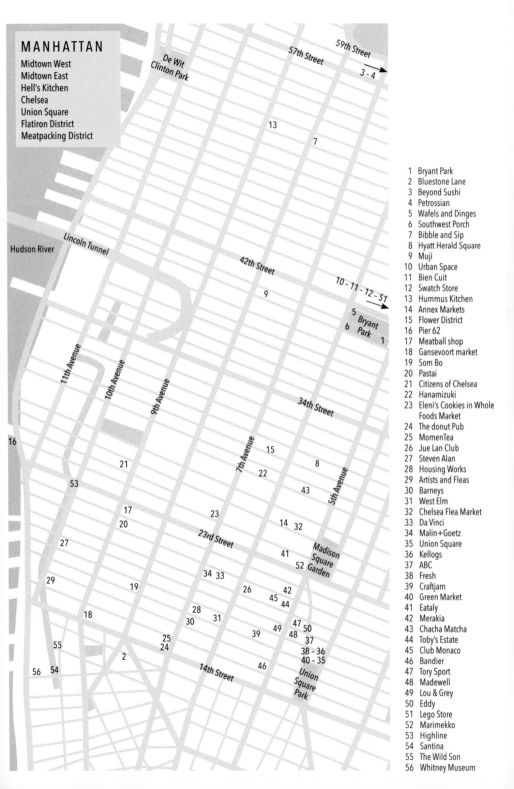

MANHATTAN

Midtown West
Midtown East
Hell's Kitchen
Chelsea
Union Square
Flatiron District
Meatpacking District

57th Street
59th Street
De Wit Clinton Park
3 - 4
13
7
42nd Street
9
10 - 11 - 12 - 51
5 Bryant Park
6
1
Lincoln Tunnel
Hudson River
34th Street
11th Avenue
10th Avenue
9th Avenue
7th Avenue
5th Avenue
16
15
8
21
22
53
43
17
23
20
14 32
27
23rd Street
Madison Square Garden
41
52
29
19
34 33
26
42
18
28 31
45 44
30
39 49 48 47 50
25
38 - 36
24
37
2
40 - 35
55
14th Street
46
Union Square Park
56 54

1 Bryant Park
2 Bluestone Lane
3 Beyond Sushi
4 Petrossian
5 Wafels and Dinges
6 Southwest Porch
7 Bibble and Sip
8 Hyatt Herald Square
9 Muji
10 Urban Space
11 Bien Cuit
12 Swatch Store
13 Hummus Kitchen
14 Annex Markets
15 Flower District
16 Pier 62
17 Meatball shop
18 Gansevoort market
19 Som Bo
20 Pastai
21 Citizens of Chelsea
22 Hanamizuki
23 Eleni's Cookies in Whole Foods Market
24 The donut Pub
25 MomenTea
26 Jue Lan Club
27 Steven Alan
28 Housing Works
29 Artists and Fleas
30 Barneys
31 West Elm
32 Chelsea Flea Market
33 Da Vinci
34 Malin+Goetz
35 Union Square
36 Kellogs
37 ABC
38 Fresh
39 Craftjam
40 Green Market
41 Eataly
42 Merakia
43 Chacha Matcha
44 Toby's Estate
45 Club Monaco
46 Bandier
47 Tory Sport
48 Madewell
49 Lou & Grey
50 Eddy
51 Lego Store
52 Marimekko
53 Highline
54 Santina
55 The Wild Son
56 Whitney Museum

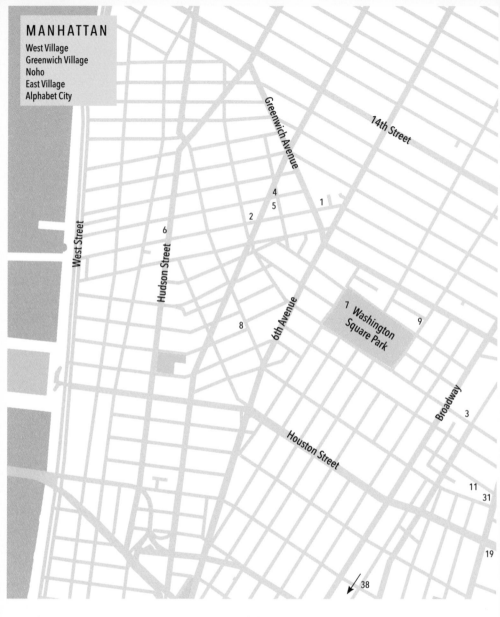

MANHATTAN

West Village
Greenwich Village
Noho
East Village
Alphabet City

14th Street

Greenwich Avenue

West Street

Hudson Street

6th Avenue

1 Washington Square Park

Broadway

Houston Street

4
5
1
2
6
8
9
3
11
31
19
38

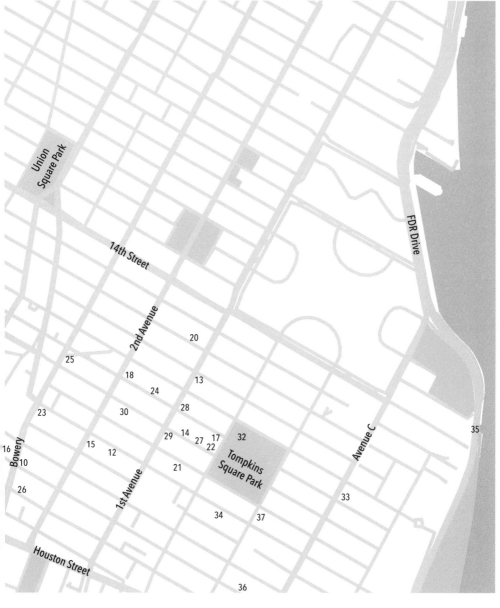

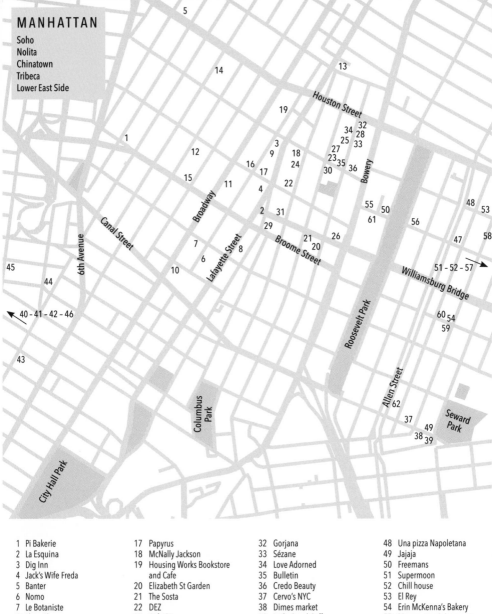

MANHATTAN

Soho
Nolita
Chinatown
Tribeca
Lower East Side

1 Pi Bakerie	17 Papyrus	32 Gorjana	48 Una pizza Napoletana
2 La Esquina	18 McNally Jackson	33 Sézane	49 Jajaja
3 Dig Inn	19 Housing Works Bookstore	34 Love Adorned	50 Freemans
4 Jack's Wife Freda	and Cafe	35 Bulletin	51 Supermoon
5 Banter	20 Elizabeth St Garden	36 Credo Beauty	52 Chill house
6 Nomo	21 The Sosta	37 Cervo's NYC	53 El Rey
7 Le Botaniste	22 DEZ	38 Dimes market	54 Erin McKenna's Bakery
8 Flour Shop	23 Cafe Gitane	39 Little Canal Coffee	55 Morgenstern's Ice cream
9 Matcha Bar	24 Lighthouse Outpost	40 Pier 25	56 Jadis
10 La Mercerie	25 Tacombi	41 Pier 26	57 The Rising States
11 AllSaints	26 De Maria	42 Staple Street	58 Reformation
12 Saint Laurent	27 Milk Bar Store	43 Tiny's	59 Top Hat
13 Kith	28 Toms	44 Gotan	60 Tictail Market
14 Mansur Graviel	29 Cozy Project	45 Bubby's	61 Green Fingers Market
15 Kate Spade	30 Little Cupcake Bakeshop	46 Juice Press	62 CW Pencil Enterprise
16 MoMa Store	31 Bar Pa Tea	47 Sauce	

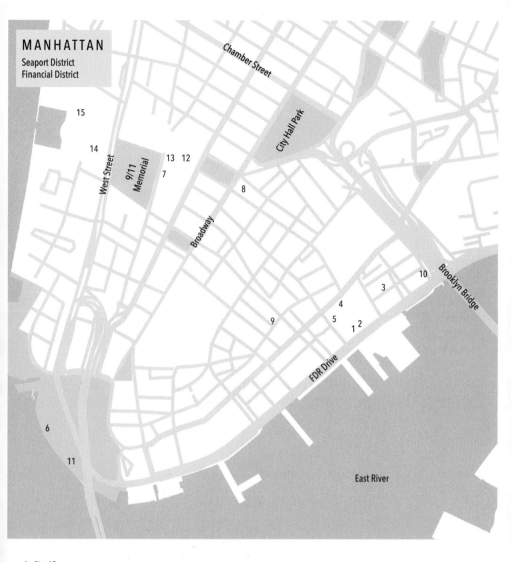

MANHATTAN

Seaport District
Financial District

1 Pier 15
2 Fulton Stall Market
3 Van Leeuwen
4 Scotch and Soda
5 Seaport Museum
6 Battery Park
7 The Oculus at Westfield World Trade
8 Noon
9 Terri
10 Cowgirl Seahorse
11 Table Green
12 And Other Stories
13 Cos
14 Flowers By Yasmine
15 Brookfield Place

Clockwise from left:
#LiveWorkCreate at @BrooklynIndustries (Park Slope, Brooklyn)
#FleaMarket by @BKFlea (Dumbo, Brooklyn)
#BentoBox at @WasanBrooklyn (Park Slope, Brooklyn)
#RooftopDrinks at the @WytheHotel (Williamsburg, Brooklyn)
Opposite Page:
#VintagePurses at @DobbinStCoop (Greenpoint, Brooklyn)

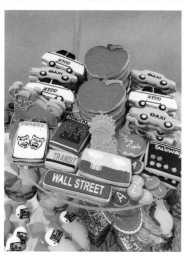

Clockwise from left:
#BabyTomatoes at @UnSqGreenMarket (Union Square, Manhattan)
#Jewelry at @BrooklynCharm (Williamsburg, Brooklyn)
#MiniVan (Carroll Gardens, Brooklyn)
#CookiesArt by @ElenisNY at Whole Foods Market (Chelsea, Manhattan)
Opposite Page:
#Rainbow of dishes at @FishsEddyNYC (Flatiron District, Manhattan)

Clockwise from left:
#VintageCar (Cobble Hill, Brooklyn)
#HissCat mural by @Hissxx (Williamsburg, Brooklyn)
#FrenchLife in the city at @Maison.Francaise of NYU (Greenwich Village, Manhattan)
Always smiling on a #RainyDay (Caroll Gardens, Brooklyn)
Opposite Page:
#FireEscape (Chinatown, Manhattan)

Clockwise from left:
#ParkingProblems (Williamsburg, Brooklyn)
#AlwaysReading at @CodexBooks (East Village, Manhattan)
Cutest #Townhouse at @TinysNYC (Tribeca, Manhattan)
#CroqueMadame at @Provence_En_Boite (Carroll Gardens, Brooklyn)
Opposite Page:
#FeministPower by@PhoebeNewYork (East Village, Manhattan)

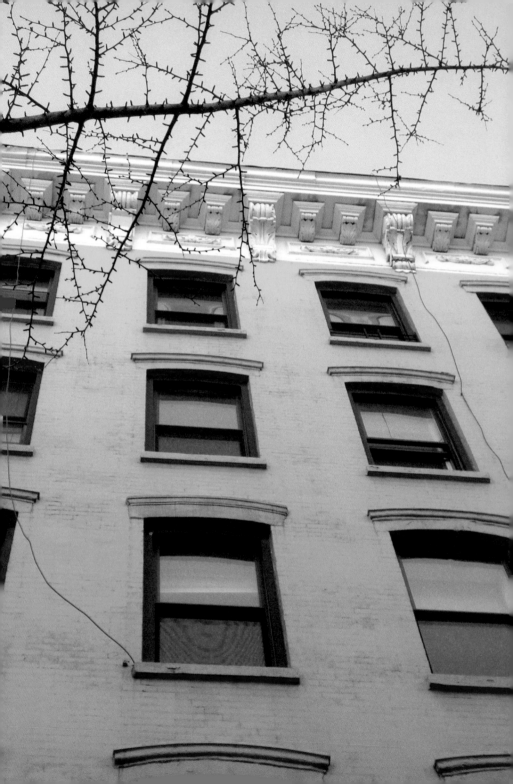

Clockwise from left:

#ItalianFastFood at @TheSosta (Nolita, Manhattan)

#CoffeeAndFlowers at @RoseAndBasil (East Village, Manhattan)

#BeetHummus Toast at @BlueStoneLaneCoffee (Midtown West, Manhattan)

#HalloweenDogParade at Tompkins Square Park (Alphabet City, Manhattan)

Opposite Page: #Pinkhouse (East Village, Manhattan)

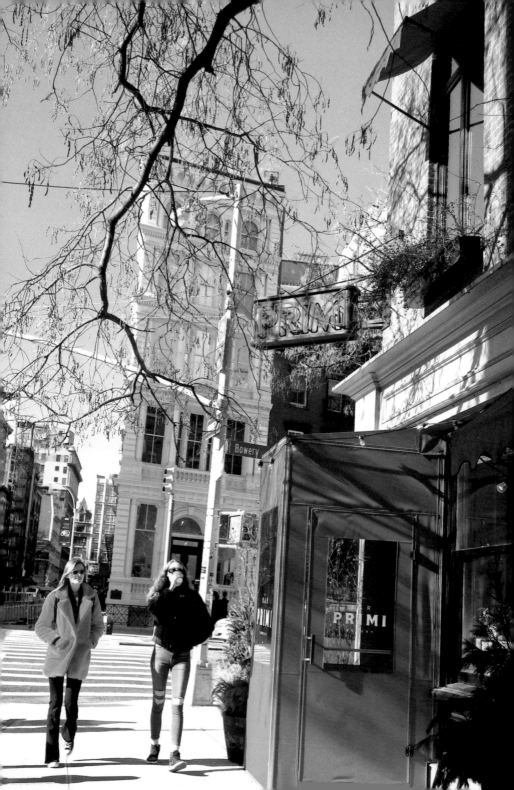

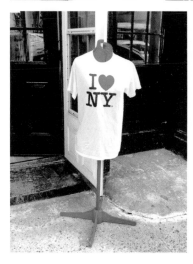

Clockwise from left:

#OhHello (Williamsburg, Brooklyn)

#NoodleSoup at @VeryFreshNoodles (Chelsea, Manhattan)

#ParkLife at @TheBatteryNYC (Battery Park City, Manhattan)

#ILoveNY fever (all around Manhattan)

Opposite Page:

#Foodism at @BarPrimi (East Village, Manhattan)

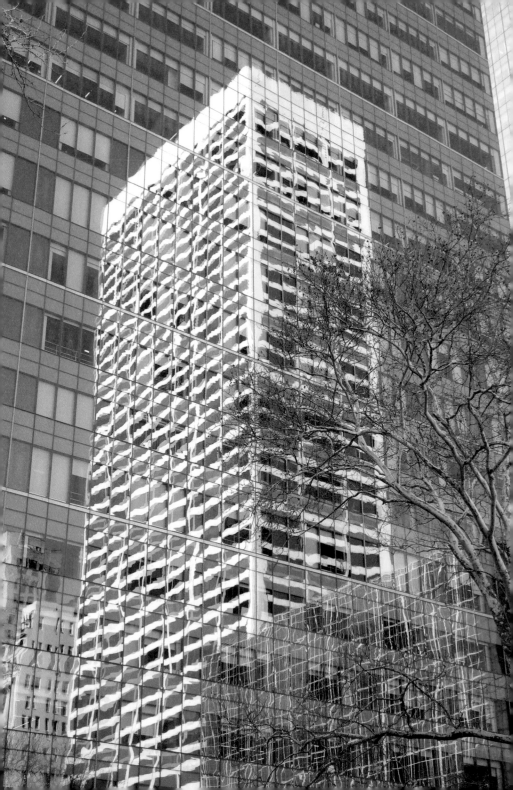

Clockwise from left:
#FlowerDistrict stroll (Chelsea, Manhattan)
#FireEscape (West Harlem, Manhattan)
#Wolverines Mascot (East Harlem, Manhattan)
#BrooklynCoffee at the @ExtractionLab (Sunset Park, Brooklyn)
Opposite Page:
#FromWhereIStand in Bryant Park (Midtown East, Manhattan)

Clockwise from left:
#DiningAlFresco at @PizzaBeach (Upper East Side, Manhattan)
#Geewhiskers cutie by @FancySeeingSarah (Williamsburg, Brooklyn)
#MagicFood at @AbracadabraBrooklyn (Bushwick, Brooklyn)
#VeganSushi at @BeyondSushiNYC (Midtown West, Manhattan)
Opposite Page:
#Mannequin at @DreamFishingTackle (Greenpoint, Brooklyn)

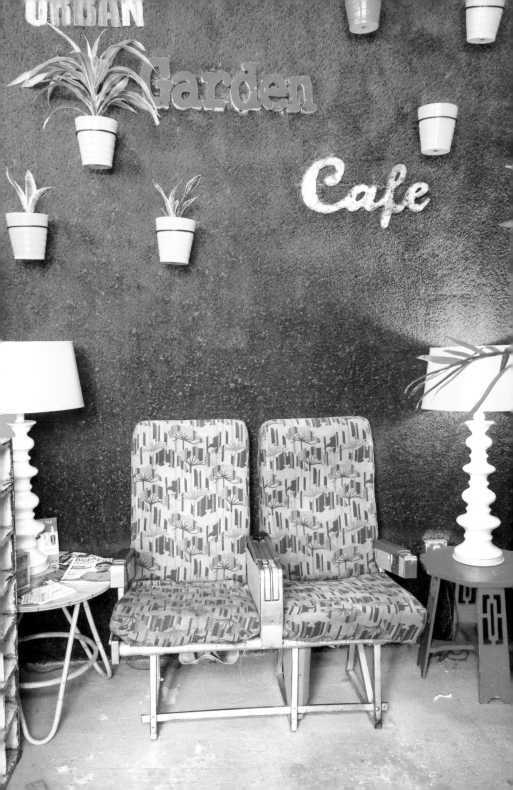

Clockwise from left:
#FalafelPita at @InTheDez (Nolita, Manhattan)
#PencilShop at @CWPencilEnterprise (Lower East Side, Manhattan)
#Mug selection at @Anthropologie (Upper East Side, Manhattan)
#Halloween is no joke (Park Slope, Brooklyn)
Opposite Page:
#UrbanGarden at @UGCEats (East Harlem, Manhattan)

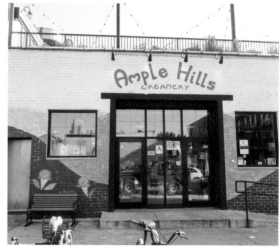

Clockwise from left:
#FreshFlowers (Upper West Side, Manhattan)
#IHaveThisThingWithDoors (West Harlem, Manhattan)
#IceCream on a rooftop at @AmpleHills (Gowanus, Brooklyn)
#MonkeyLove at @WestElmChelsea (Chelsea, Manhattan)
Opposite Page:
#OutsideDining at @HummusKitchen9thAve (Hell's Kitchen, Manhattan)

Clockwise from left:
#SidewalkArt (Williamsburg, Brooklyn)
#Mantra on a dish towel by @Blue_Q at @MuseumofCityNY (East Harlem, Manhattan)
#RainbowWalls (Bushwick, Brooklyn)
#GiftIdeas at Red Pearl (Williamsburg, Brooklyn)
Opposite Page:
#CherryBlossom at @BrooklynBotanic (Crown Heights, Brooklyn)

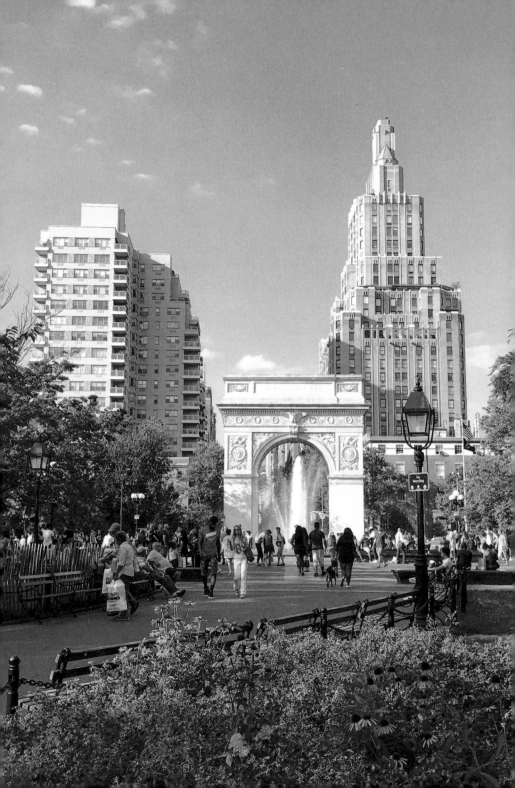

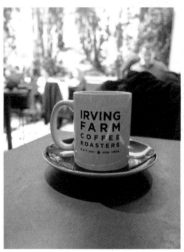

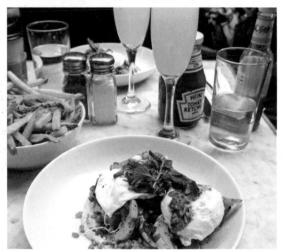

Clockwise from left:
#LunchTime in @BryantParkNYC at @SouthWestPorchNYC (Midtown West, Manhattan)
#FlowerPath (Tribeca, Manhattan)
#MimosaSunday at @Cafe_Colette (Williamsburg, Brooklyn)
#CozyCoffee at @IrvingFarm (Upper West Side, Manhattan)
Opposite Page:
#WashingtonSquarePark (Greenwich Village, Manhattan)

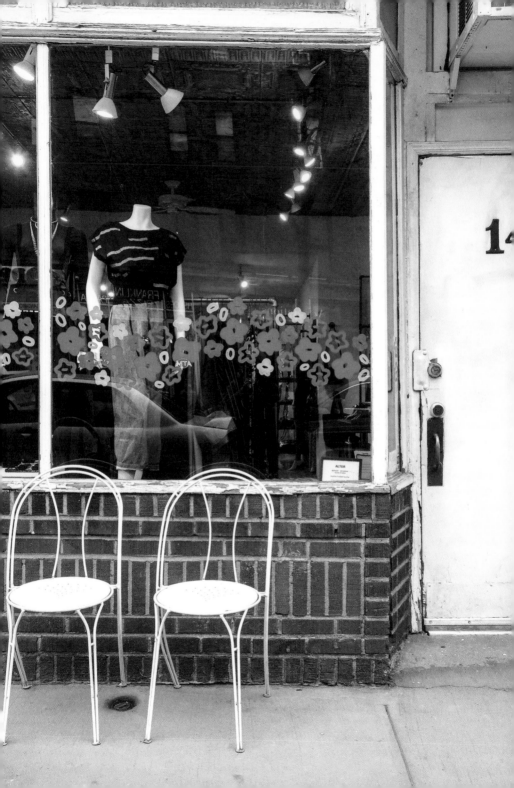

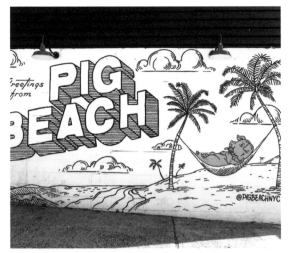
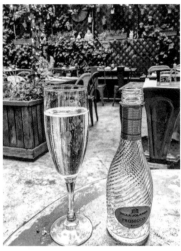
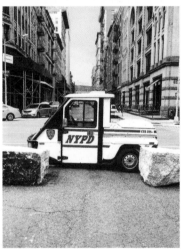

Clockwise from left:
#OutsideBar and #BBQ @PigBeachNYC (Gowanus, Brooklyn)
#Prosecco at @PMF_NYC (Alphabet City, Manhattan)
#Brunch at @SettePaniNYC (West Harlem, Manhattan)
#PoliceCar (Tribeca, Manhattan)
Opposite Page:
#FlowerPower at @AlterBrooklyn (Greenpoint, Brooklyn)

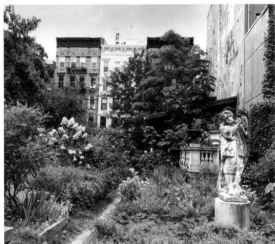

Clockwise from left:
#CurryRamen at @Souen_NYC (East Village, Manhattan)
#MakingFriends at 9th St Community Garden Park (East Village, Manhattan)
#UrbanJungle at @ElizabethStreetGarden (Nolita, Manhattan)
#StickerArt by @Morgan_Jesse_Lappin (Lower East Side, Manhattan)
Opposite Page:
#VintageCar (West Harlem, Manhattan)

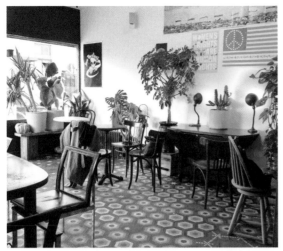
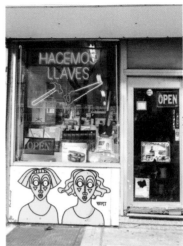
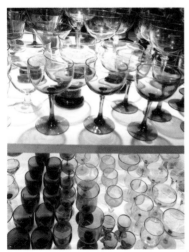
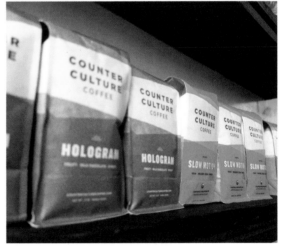

Clockwise from left:
#ChocolateCupcakes at @BakeShop_Bushwick (Bushwick, Brooklyn)
#StreetArt by @SaraErenthalArt (Bushwick, Brooklyn)
#DecafTime from @CounterCultureCoffee at the
@DoubleDutchEspresso (Harlem, Manhattan)
#Shelfie at @ABCCarpetAndHome (Union Square, Manhattan)
Opposite Page:
#BestInTown at @BlackSeedBagels (East Village, Manhattan)

"LADIES AND GENTLEMEN.

THE VERY WORD SECRECY IS REPUGNANT IN A FREE AND OPEN SOCIETY AND WE ARE AS A PEOPLE, INHERENTLY AND HISTORICALLY OPPOSED TO SECRET SOCIETIES, TO SECRET OATHS AND TO SECRET PROCEEDINGS WE DECIDED LONG AGO THAT THE DANGERS OF EXCESSIVE AND UNWARRANTED CONCEALMENT OF PERTINENT FACTS FAR OUTWEIGH THE DANGERS WHICH ARE CITED TO JUSTIFY IT. FOR WE ARE OPPOSED AROUND THE WORLD BY A MONOLITHIC AND RUTHLESS CONSPIRACY THAT RELIES PRIMARILY ON COVERT MEANS FOR EXPANDING ITS SPHERE OF INFLUENCE ON INFILTRATION INSTEAD OF INVASION, ON SUBVERSION INSTEAD OF ELECTIONS ON INTIMIDATION INSTEAD OF FREE CHOICE IT IS A SYSTEM WHICH HAS CONSCRIPTED VAST HUMAN AND MATERIAL RESOURCES INTO THE BUILDING OF A TIGHTLY KNIT HIGHLY EFFICIENT MACHINE THAT COMBINES MILITARY, DIPLO-MATIC, INTELLIGENCE, ECONOMIC, SCIENTIFIC AND POLITICAL OPERATIONS. ITS PREPARATIONS ARE CONCEALED NOT PUBLISHED. ITS MISTAKES ARE BURIED, NOT HEAD LINED, ITS DISSENTERS ARE SILENCED, NOT PRAISED, NO EXPENDITURE IS QUESTIONED NO RUMOR IS PRINTED, NO SECRET IS REVEALED TODAY THERE IS LITTLE VALUE IN ASSURING THE SURVIVAL OF OUR NATION IF OUR TRA-DITIONS DO NOT SURVIVE WITH IT. WITHOUT DEBATE, WITHOUT CRITICISM, NO ADMINISTRATION AND NO COUNTRY CAN SUCCEED, AND NO REPUBLIC CAN SURVIVE. THAT IS WHY THE ATHENIAN LAWMAKER, SOLON, DECREED IT A CRIME FOR ANY CITIZEN TO SHRINK FROM CONTROVERSY. THAT IS WHY OUR PRESS WAS PROTECTED BY THE FIRST AMENDMENT, THE ONLY BUSINESS IN AMERICA SPECIFICALLY PROTECTED BY THE CONSTITUTION NOT PRIMARILY TO AMUSE AND TO ENTERTAIN, NOT TO EMPHASIS THE TRIVIA, THE SENTI-MENTAL, NOT TO SIMPLY GIVE THE PUBLIC WHAT IT WANTS, BUT TO INFORM, TO AROUSE, TO REFLECT TO STATE OUR DANGERS AND OUR OPPORTUNITIES TO INDICATE OUR CRISIS AND OUR CHOICES, TO LEAD, MOLD, EDUCATE AND SOMETIMES EVEN ANGER PUBLIC OPINION. THIS MEANS GREATER COVERAGE AND ANALYSIS OF INTERNATIONAL NEWS, FOR IT IS NO LONGER FAR AWAY AND FOREIGN, BUT CLOSE AT HAND AND LOCAL IT MEANS GREATER ATTENTION TO IMPROVE THE UNDERSTANDING OF THE NEWS AS WELL AS IMPROVE TRANS-MISSION. AND IT MEANS FINALLY THAT GOVERNMENT AT ALL LEVELS MUST MEET ITS OBLIGATION TO PROVIDE YOU WITH THE FULLEST POSSIBLE INFORMATION OUTSIDE THE NARROWEST LIMITS OF NATIONAL SECURITY BUT I AM ASKING YOUR HELP IN THE TREMENDOUS TASK OF INFORMING AND ALERTING THE AMERICAN PEOPLE, FOR I HAVE COMP-LETE CONFIDENCE IN THE RESPONSE AND DEDICATION OF OUR CITIZENS WHENEVER THEY ARE FULLY INFORMED. CONFIDENT THAT WITH YOUR HELP, MAN WILL BE WHAT HE WAS BORN TO BE, FREE AND INDEPENDENT."

DAVID HOLLIER

MMXV.

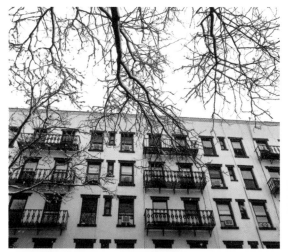

Clockwise from left:
#SnowDay kind of light (East Village, Manhattan)
#FreshPasta at @EatalyFlatiron (Flatiron District, Manhattan)
#WallDecor at @AllSaints (Soho, Manhattan)
#LightAtTheEndOfTheTunnel (East Harlem, Manhattan)
Opposite Page:
#MrPresident by @DavidHollierArt (Greenpoint, Brooklyn)

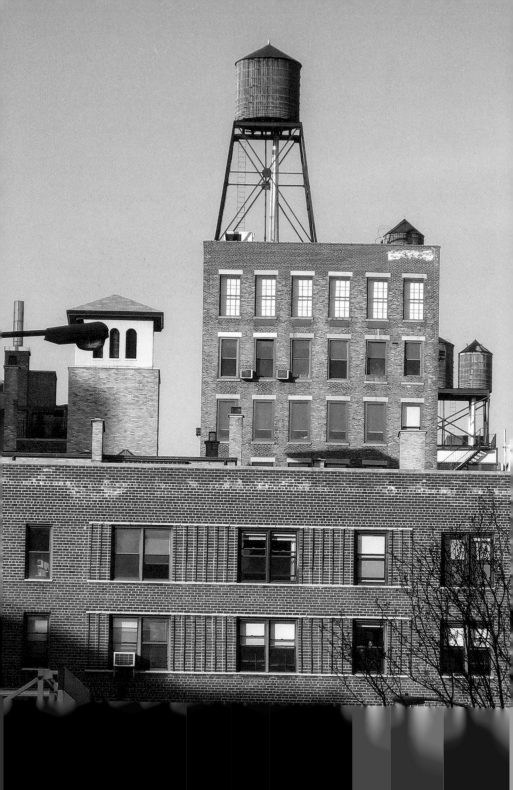

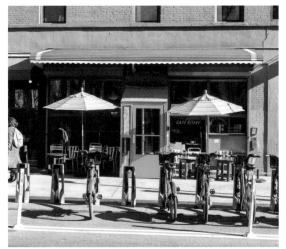
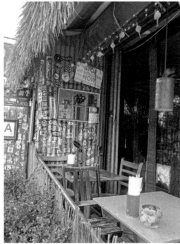
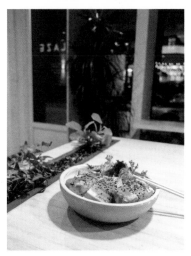

Clockwise from left:
#LunchOutside at @CafeGitaneNY (Nolita, Manhattan)
#TikiTime at @SurfBarBrooklyn (Williamsburg, Brooklyn)
#SupperClub at @GuadalupeInnBKn (Bushwick, Brooklyn)
#TeriyakiBowl at @GlazeTeriyaki (Williamsburg, Brooklyn)
Opposite Page:
#Watertower (Noho, Manhattan)

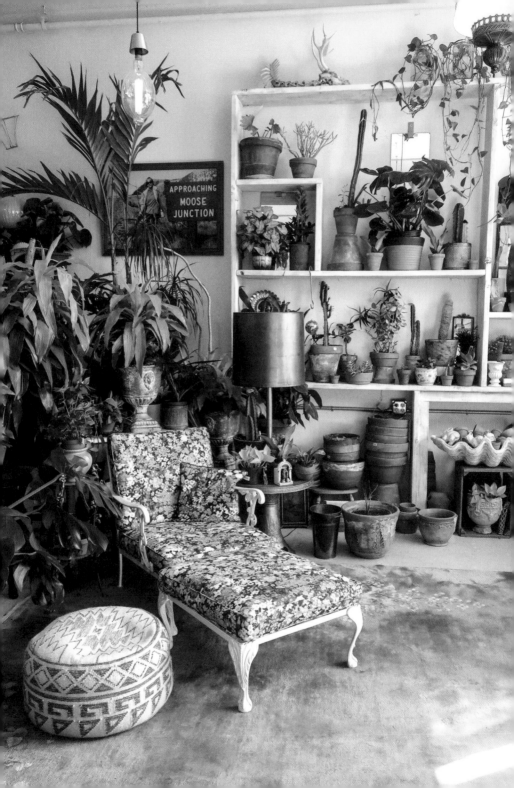

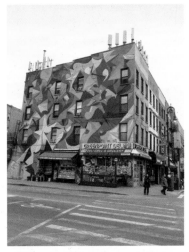

Clockwise from left:
#PoshStyle at @Eclectic_CollectiblesNY (Williamsburg, Brooklyn)
#NYCMurals (Greenpoint, Brooklyn)
#AvocadoToast at @SwallowCafeNYC (Cobble Hill, Brooklyn)
#Pavement at @Columbia University (West Harlem, Manhattan)
Opposite Page:
#ExoticPlants at @FengSway (Greenpoint, Brooklyn)

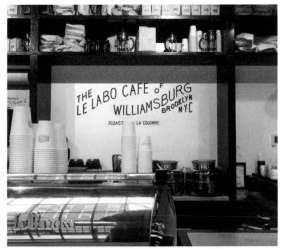

Clockwise from left:
#ServingFrenchPress at @LeLaboFragrances (Williamsburg, Brooklyn)
#MediterraneanFood at @MarlowBistro (Upper West Side, Manhattan)
WaterTower (Williamsburg, Brooklyn)
#BooksAndCoffee at @MolassesBooks (Bushwick, Brooklyn)
Opposite Page:
#VintageJewelry at @AnnexMarkets (Chelsea, Manhattan)

Clockwise from left:
#PeaceInTheCity (Upper West Side, Manhattan)
#HummusBowl at @HoneyBrainsLife (Noho, Manhattan)
#FrenchBrunch at @FrenchLouieNYC (Boerum Hill, Brooklyn)
#CerealMilkIceCream at @MilkBarStore (Nolita, Manhattan)
Opposite Page:
#ModernArt at @WhitneyMuseum (Meatpacking District, Manhattan)

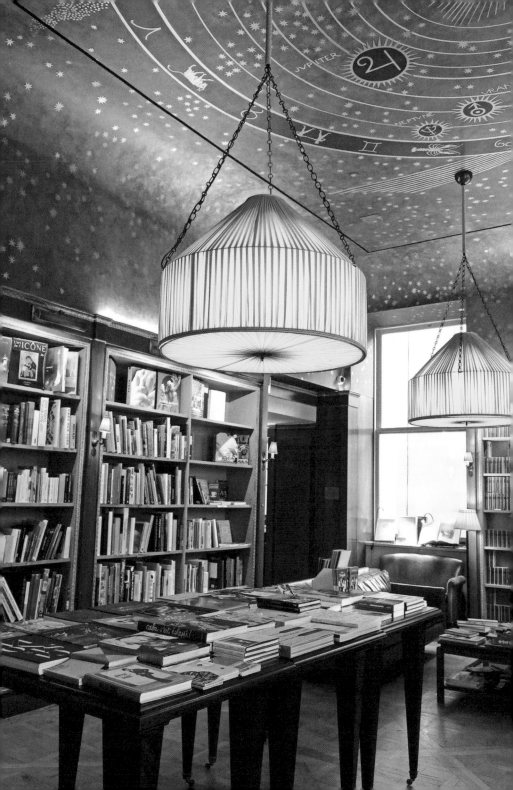

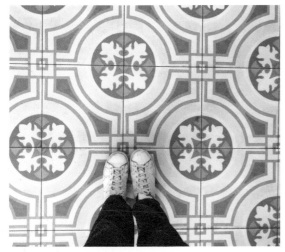
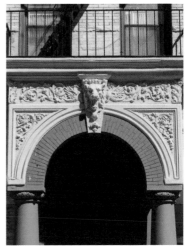
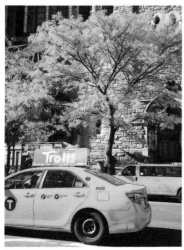
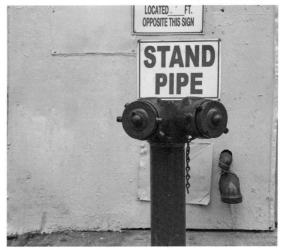

Clockwise from left:
#IHaveThisThingWithTiles at @OneGirlCookies (Sunset Park,
Brooklyn)
#YellowHouse (West Harlem, Brooklyn)
#StandPipe (East Village, Manhattan)
#SpringHasSprung (Upper West Side)
Opposite Page:
 #ReadingRoom at @AlbertineBooks (Upper East Side, Manhattan)

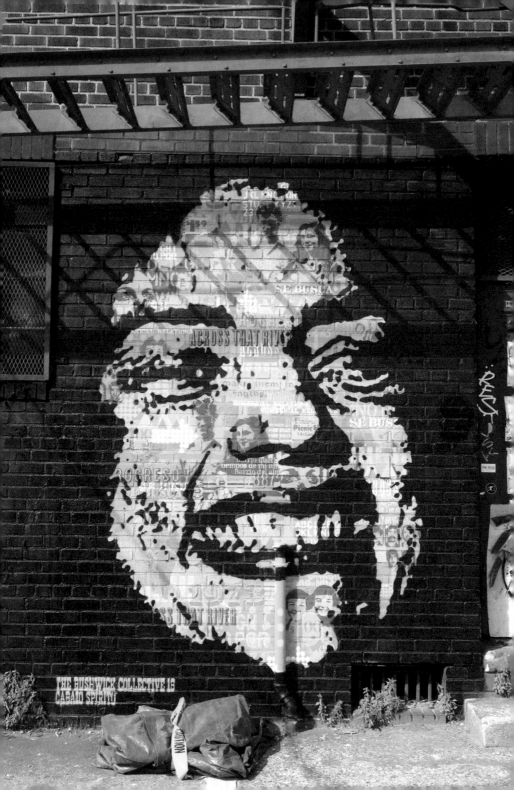

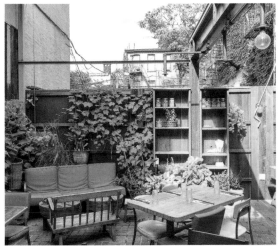

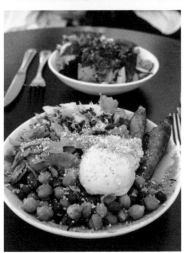

Clockwise from left:
#VietnameseFood at @BricolageBK (Park Slope, Brooklyn)
#BrooklynBestPizza at @RobertasPizza (Bushwick, Brooklyn)
#SwedishCoffee from @Konditori (Park Slope, Brooklyn))
#MonkeyBowl at @DeMariaNYC (Nolita, Manhattan)
Opposite Page:
#Mural by @CabaioSpirito (Bushwick, Brooklyn)

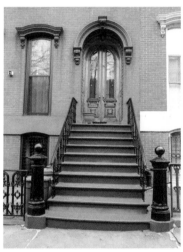

Clockwise from left:
#ItalianToGo at @Diviera_Drive_NYC (Williamsburg, Broolkyn)
#LeatherGoods at @ShopClareV (Cobble Hill, Brooklyn)
#HipsterFrenchie named @WhatsUpGordy (Williamsburg, Brooklyn)
#DoorsOfInstagram (East Harlem, Manhattan)
Opposite Page:
#ChairsChairsChairs at @JunkBrooklyn (Williamsburg, Brooklyn)

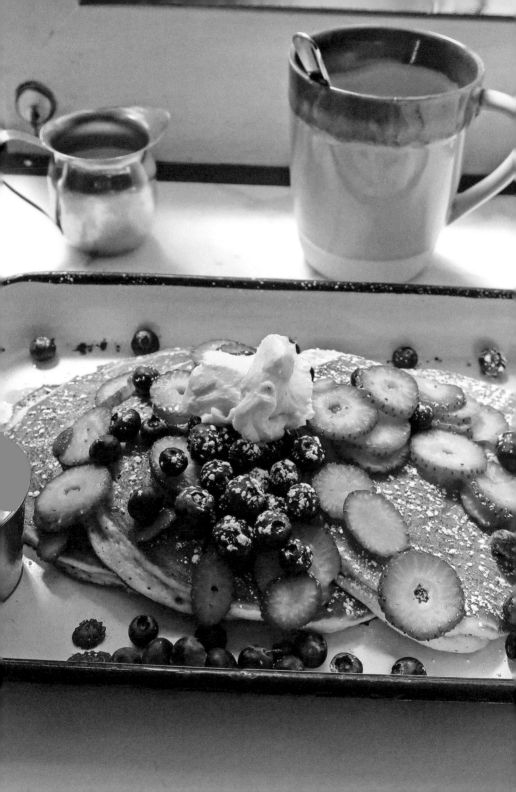

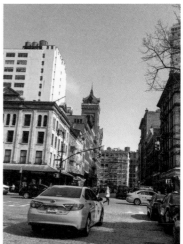
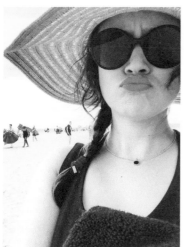
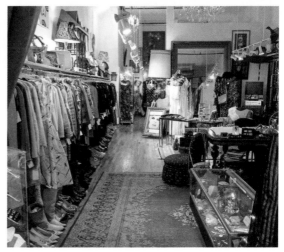

Clockwise from left:
#VintageSign (Upper West Side, Manhattan)
#TribecaBuildings (Tribeca, Manhattan)
Vintage #Treasures at @LeGrandStrip (Williamsburg, Brooklyn)
#WhereIsTheSun (Rockaway Beach, Queens)
Opposite Page:
#ButtermilkPancakes at @TheWildSonNYC (Meatpacking District, Manhattan)

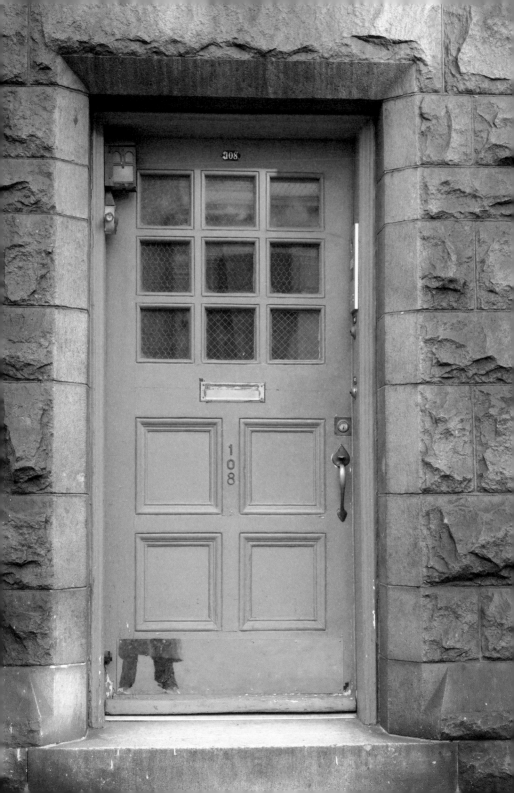

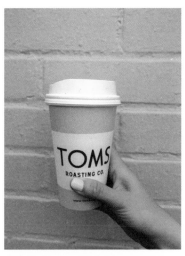

Clockwise from left:
#Greenery by @El_Cekis (East Harlem, Manhattan)
#FairTradeCoffee at @Toms (Nolita, Manhattan)
#BeachVolley at Pier 25 at @HudsonRiverPark (Tribeca, Manhattan)
#HighSchool Field (East Harlem, Manhattan)
Opposite Page:
#BlueDoor (West Village, Manhattan)

Clockwise from left:
#MuchLove at @FreshBeauty (Union Square, Manhattan)
#ImpossibleBurger at @BareBurger (Upper East Side, Manhattan)
#Cuteness at @FriendsNYC (Bushwick, Brooklyn)
#BeautyProducts at @AndOtherStories (Financial District, Manhattan)
Opposite Page:
@Diptyque Pop-up at @ClubMonaco (Flatiron District, Manhattan)

Clockwise from left:
#SundayTea and #Crepes at @Little_Choc (Williamsburg, Brooklyn)
#ChildhoodThrowback by @RaddingtonFalls (Bed-Stuy, Brooklyn)
#VintageBeauty (Greenpoint, Brooklyn)
#HipFashion at @ShopLadidadee (Williamsburg, Brooklyn)
Opposite Page:
#Pearls at @AnnexMarkets (Hell's Kitchen, Manhattan)

BROOKLYN
WINE
CELLAR

WINE BY THE GLASS

WINE
BY THE
GLASS

FRIED
PIZZA

WINE BY

THE GLASS

BROOKLYN
WINE
CELLAR

DRINK WHILE

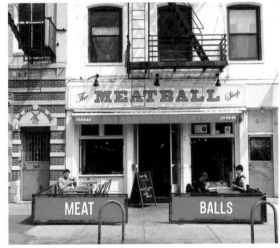

Clockwise from left:
#GoodFun (Greenpoint Brooklyn)
#MorningFuel at @AllegroCoffee (East Village, Manhattan)
#MeatBallShop at @MeatBallers (Chelsea, Manhattan)
#GarageDoors (East Harlem, Manhattan)
Opposite Page:
@BrooklynWineCellar at the @DekalbMarketHall (Fort Greene, Brooklyn)

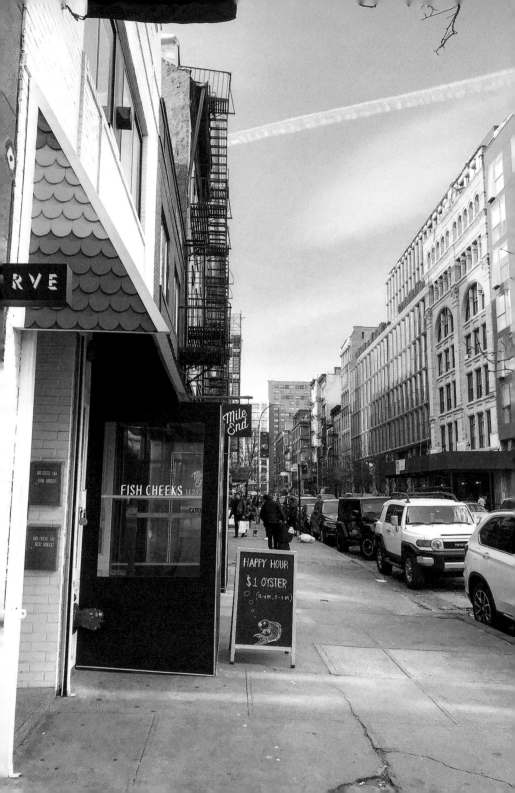

Clockwise from left:

#LifeInColors (Boerum Hill, Brooklyn)

#HazelnutIceCream at @AlberoDeiGelatiNY (Park Slope, Brooklyn)

#ThriftSoreFinds at @HousingWorks (Chelsea, Manhattan)

#Pins and #Jewelry at @CultPartyNYC (Bushwick, Brooklyn)

Opposite Page:

#ThaiSeaFood at @FishCheeksNYC (Noho, Manhattan)

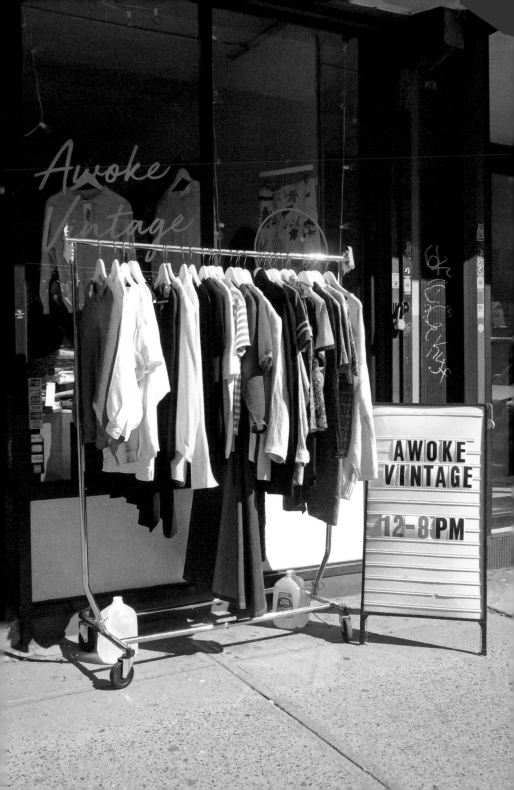

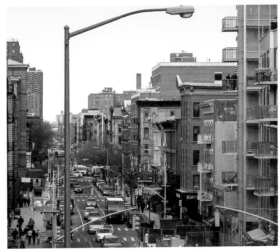

Clockwise from left:
#Antiques at @TheUpperRust (West Village, Manhattan)
#Tulips at Pier 62 at @HudsonRiverPark (Chelsea, Manhattan)
#CityView (East Harlem, Manhattan)
#DiveBar Style at @HanksSaloon (Boerum Hill, Brooklyn)
Opposite Page:
#VintageFashion at @AwokeVintageBrooklyn (Williamsburg, Brooklyn)

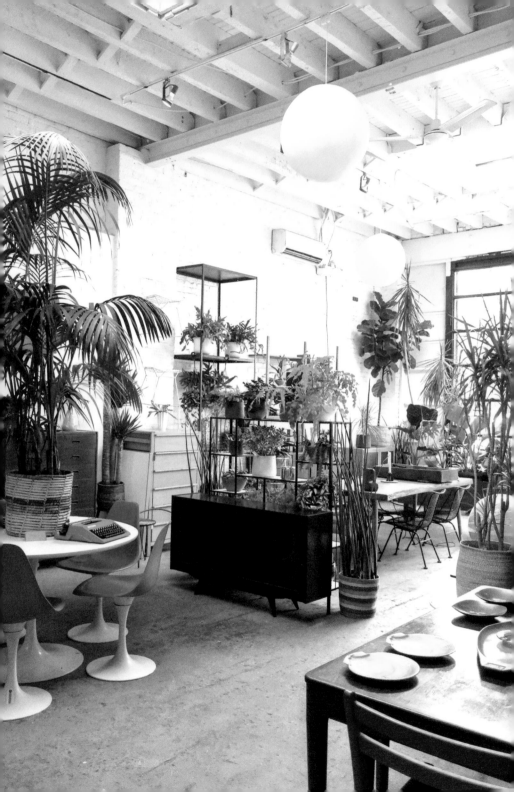

Clockwise from left:
#LocalDesigners and #Vintage at @ArtistsAndFleas (Williamsburg, Brooklyn)
#Shopping at @UpstateStock (Williamsburg, Brooklyn)
#CentralParkPicnic (Upper East Side, Manhattan)
#HotSauce Paradise at @Heatonist (Williamsburg, Brooklyn)
Opposite Page:
#Plants and #Furniture at @OtherTimesVintage (Bushwick, Brooklyn)

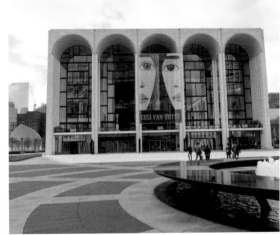

Clockwise from left:
#FoodHall with style at @GansevoortMarketNYC (Chelsea, Manhattan)
#HotChocolate at @LaMercerieCafe (Soho, Manhattan)
#OperaNight at the @MetOpera (Upper West Side, Manhattan)
#Cookies and #Cupcakes at @Ovenly (Williamsburg, Brooklyn)
Opposite Page:
#Margarita and #FishTacos at @RosaritoFish (Williamsburg, Brooklyn)

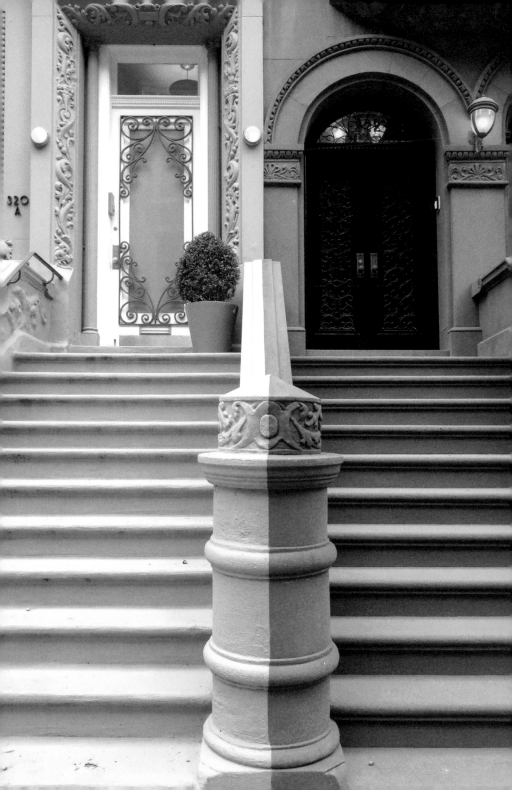

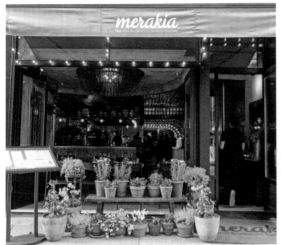

Clockwise from left:
#GreekFood at @MerakiaNYC (Flatiron District, Manhattan)
#GreenSpace by @GrowNYC (Park Slope, Brooklyn)
#GreekLunch by @PiBakerie (Soho, Manhattan)
#LatteArt at @BibbleAndSip (Midtown West, Manhattan)
Opposite Page:
#NYCHouses (Upper West Side, Manhattan)

Clockwise from left:
#PorcelaineDishes at @MudAustralia (Boerum Hill, Brooklyn)
#AsianFusion at @SomBoFood (Chelsea, Manhattan)
#NeighborhoodPark (Upper West Side, Manhattan)
#CharcoalLatte at @ProjectCozy (Nolita, Manhattan)
Opposite Page:
#NYCBuilding (Lower East Side, Manhattan)

Clockwise from left:
#Coffee and #Manicure at @ChillHouse (Lower East Side, Manhattan)
#LiveLoveLayer at @Gorjana (Soho, Manhattan)
#NYCDetails (Chelsea, Manhattan)
#PortugueseFood at @CervosNYC (Lower East Side, Manhattan)
Opposite Page:
#EmergingDesigners at @TheRisingStates (Lower East Side, Manhattan)

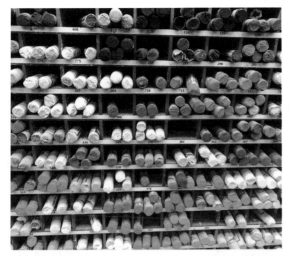

Clockwise from left:
#ArtSupplies at @DaVinciArtistSupply (Chelsea, Manhattan)
#Flowers and #Chocolate at @AtTheMeadow (West Village, Manhattan)
#Pasta at @SauceRestaurant (Lower East Side, Manhattan)
#Stationery at @TopHatNYC (Lower East Side, Manhattan)
Opposite Page:
#RedStairs (West Harlem, Manhattan)

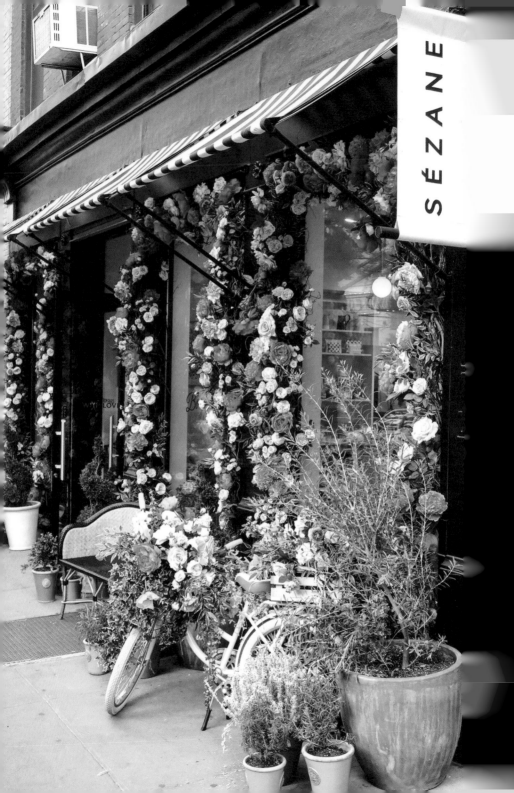

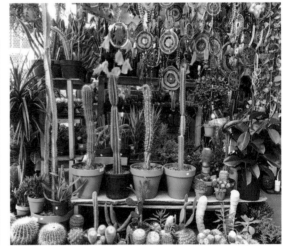

Clockwise from left:
#MedicinalPlants at @FlowerPower_NYC (East Village, Manhattan)
#WineBar at @JadisWineBar (Lower East Side, Manhattan)
#Cactus at @CrystalsGardenNYC (East Village, Manhattan)
#LocalMarket at @DimesTimes (Lower East Side, Manhattan)
Opposite Page:
#FrenchFashion at @Sezane (Nolita, Manhattan)

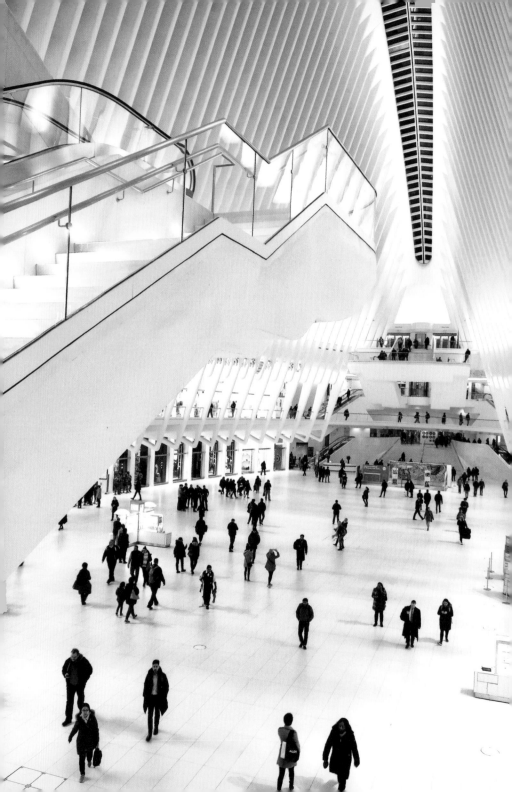

Clockwise from left:
#SohoArchitecture at the @YSL store (Soho, Manhattan)
#HaloumiEggs at @CafeMogadorNYC (East Village, Manhattan)
#PopArtStyle at @MomaDesignStore (Soho, Manhattan)
#YouAreLoved by @RaphaelCanoLove (Lower East Side, Manhattan)
Opposite Page:
@WestfieldWorldTradeCenter Shopping Mall at the #Oculus (Financial District, Manhattan)

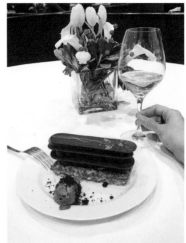
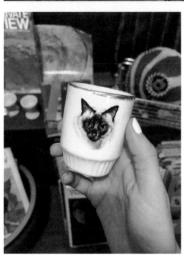
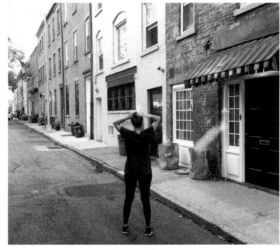

Clockwise from left:
#BrooklynBrunch at @WalterFoods (Fort Greene, Brooklyn)
#FinestDessert at @PetrossianNYC (Midtown West, Manhattan)
#Stroll on #VerandahPlace (Cobble Hill, Brooklyn)
#VintageMug at @28ScottVintage (Bushwick, Brooklyn)
Opposite Page:
@EmpireStateBldg from Herald Square (Garment District, Manhattan)

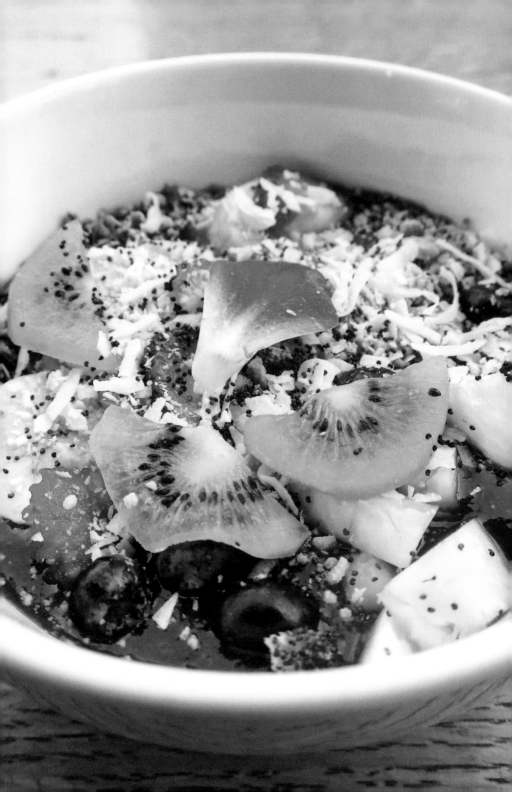

Clockwise from left:
#SurfShop at @PilgrimSurfSupply (Williamsburg, Brooklyn)
#ShoppingBags at @Baggu (Williamsburg, Brooklyn)
#MatchaLatte at @ChaChaMatcha (Flatiron District, Manhattan)
#WatchTime at @Swatch (Midtown East, Manhattan)
Opposite Page:
#AcaiBowl at @GotanNYC (Tribeca, Manhattan)

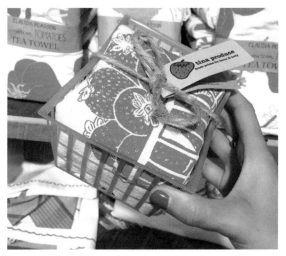

Clockwise from left:
#AvoToast at @WhileWeWereYoungNYC (West Village, Manhattan)
#DoorStep (Chelsea, Manhattan)
#DishTowel by @TinaProduce at @WholeFoodsNYC (Gowanus, Brooklyn)
#CurrentMood (Upper East Side, Manhattan)
Opposite Page:
#StrawberryPie at @TheRecolte (Upper West Side, Manhattan)

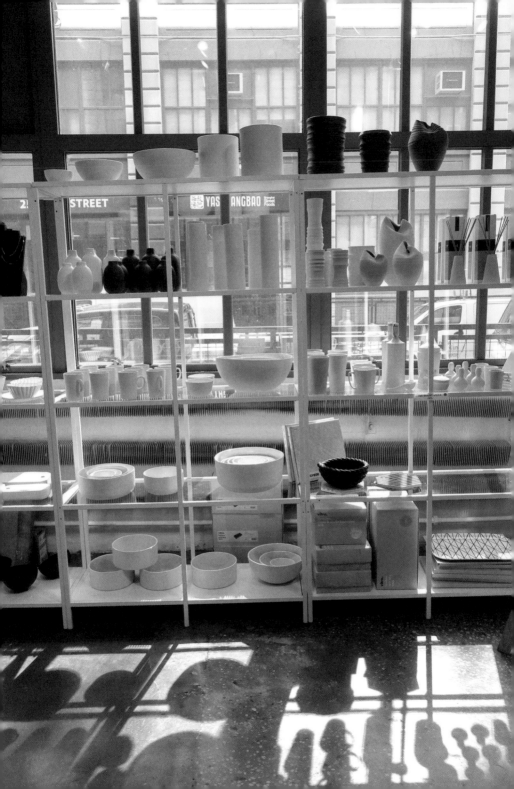

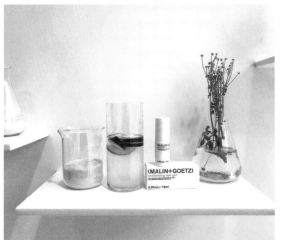
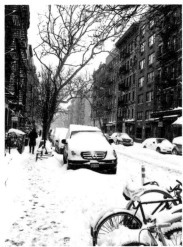

Clockwise from left:
#MinimalistBeauty at @MalinAndGoetz (Chelsea, Manhattan)
#LetItSnow (East Village, Manhattan)
#SneakerAddiction at @Kith (Soho, Manhattan)
#EmergingBrands at @Tictail (Lower East Side, Manhattan)
Opposite Page:
#HomeDecor at @WantedDesign store (Sunset Park, Brooklyn)

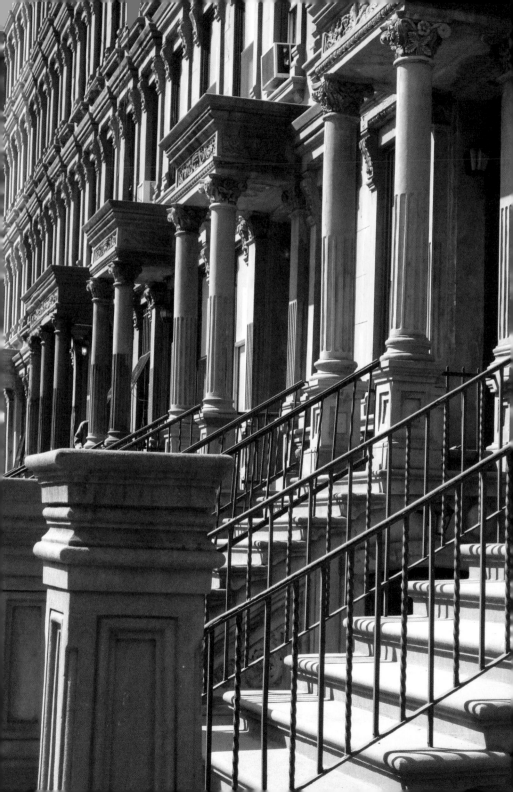

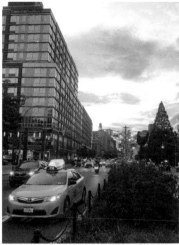

Clockwise from left:
#ArtisanalGoods at @LoveAdorned (Nolita, Manhattan)
#AfterTheRain sunset (Lower East Side, Manhattan)
#BreakfastBagel at @ThreeSeatEspresso (East Village, Manhattan)
#SoapMaker at @ArtistsAndFleas (Chelsea, Manhattan)
Opposite Page:
#NYCArchitecture (West Harlem, Manhattan)

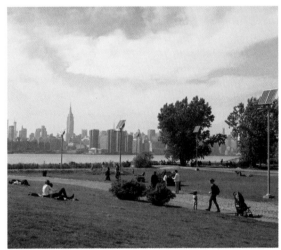

Clockwise from left:

#CoolMug from @SeltzerGoods at @BrooklynBotanic Shop (Prospect park, Brooklyn)

#BookParadise at @GreenLightBklyn (Fort Greene, Brooklyn)

#SkylineView from East River Park (Williamsburg, Brooklyn)

#Salad at @PantryMarketEatery (Long Island City, Queens)

Opposite Page:

#HandmadePasta at @PastaiNYC (Chelsea, Manhattan)

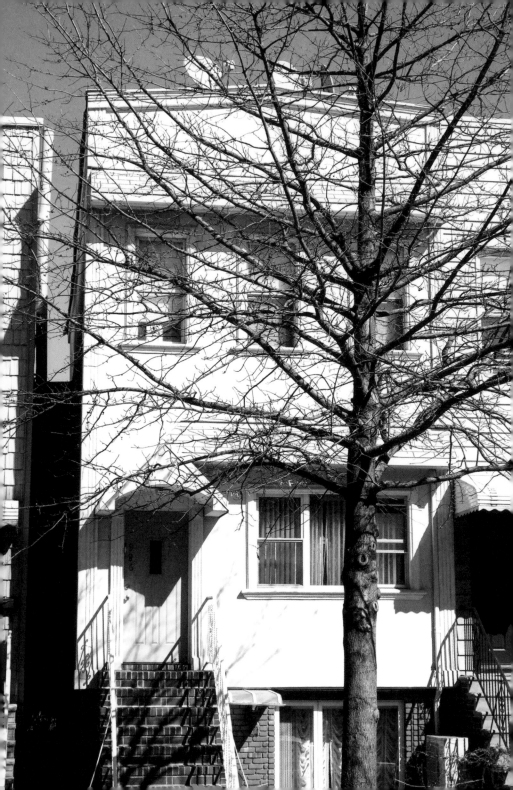

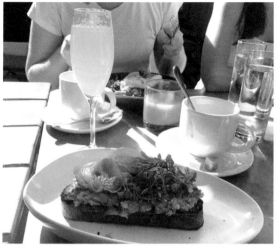
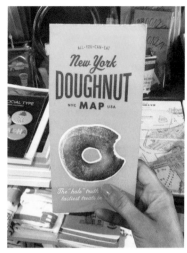
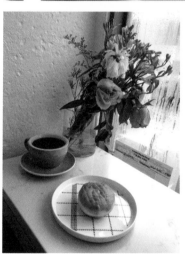

Clockwise from left:
#AvocadoToast at @SundayInBrooklyn (Williamsburg, Brooklyn)
@AllYouCanEat Doughnut Map at @AnniesBlueRibbonGeneralStore
(Park Slope, Brooklyn)
#Selfeet (Tribeca, Manhattan)
#PastryTime at @SaltwaterNYC (East Village, Manhattan)
Opposite Page:
#DreamHouse (Williamsburg, Brooklyn)

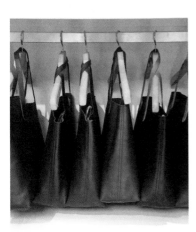

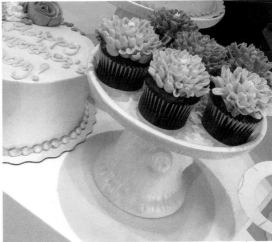

Clockwise from left:

#AmericanFashion @StevenAlan Shop (Boerum Hill, Brooklyn)

#DoorsofInstagram (Upper West Side, Manhattan)

#CupcakeArt at @EmpireCakeNYC (Chelsea, Manhattan)

#LeatherGoods at @Madewell (Flatiron District, Manhattan)

Opposite Page:

#CampusView at @Columbia University (West Harlem, Manhattan)

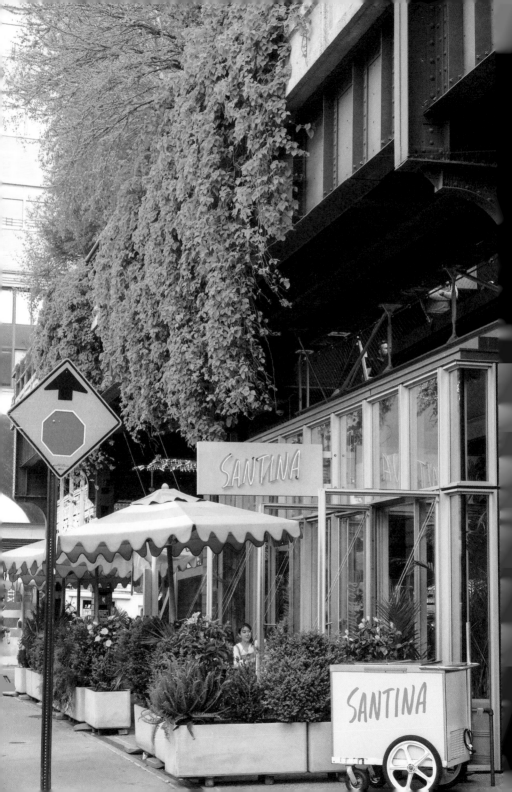

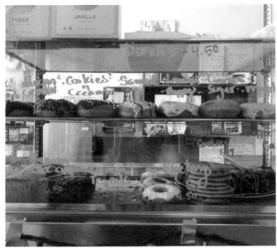

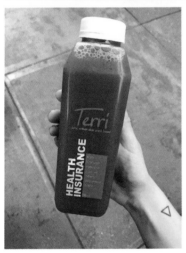

Clockwise from left:
#GlutenFreeVegan delish at @ErinMcKennasBakery (Lower East Side, Manhattan)
#DoorsOfInstagram (Long Island City, Queens)
#ArugulaPizza at @UnaPizzaNapoletana (Lower East Side, Manhattan)
#GreenJuice at @TerriRestaurant (Financial District, Manhattan)
Opposite Page:
#OutdoorDining at @SantinaNYC (Meatpacking District, Manhattan)

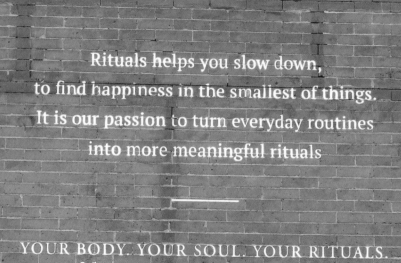

Rituals helps you slow down,
to find happiness in the smallest of things.
It is our passion to turn everyday routines
into more meaningful rituals

———

YOUR BODY. YOUR SOUL. YOUR RITUALS.

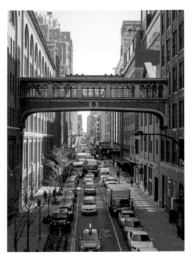

Clockwise from left:

#BrooklynLager at @BrooklynBrewery (Williamsburg, Brooklyn)

#BelgianWaffle at @WafelsAndDinges (Midtown West, Manhattan)

#LifeInColor (Upper West Side, Manhattan)

#UrbanView from the @HighlineNYC (Chelsea, Manhattan)

Opposite Page:

#TakeCareOfYourself at @RitualsCosmetics (Williamsburg, Brooklyn)

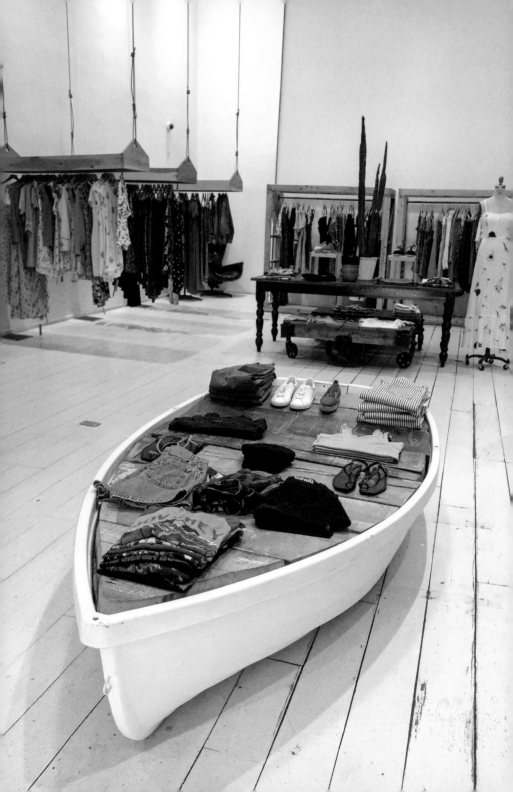

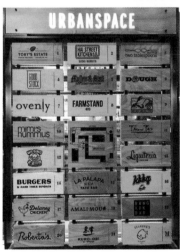
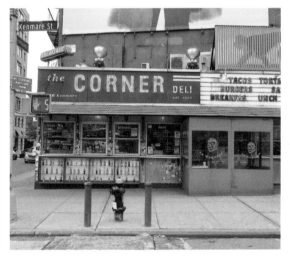

Clockwise from left:

#Donuts 24/7 at the @Donut.Pub (Chelsea, Manhattan)

#MonkeyLove at the @Lego Store (Flatiron District, Manhattan)

#Tacos and #Mezcal at @EsquinaNYC (Soho, Manhattan)

#FoodHall at @UrbanSpaceNYC (Midtown East, Manhattan)

Opposite Page:

#SustainableClothing at @Reformation (Lower East Side, Manhattan)

Clockwise from left:
#CleanFood at @Le_Botaniste (Soho, Manhattan)
#LunchSpecial at @DuJourBakery (Park Slope, Brooklyn)
#CheeseShop at @BKLYNLarder (Prospect Heights, Brooklyn)
#MonsterCar (East Harlem, Manhattan)
Opposite Page:
#Staircase (Cobble Hill, Brooklyn)

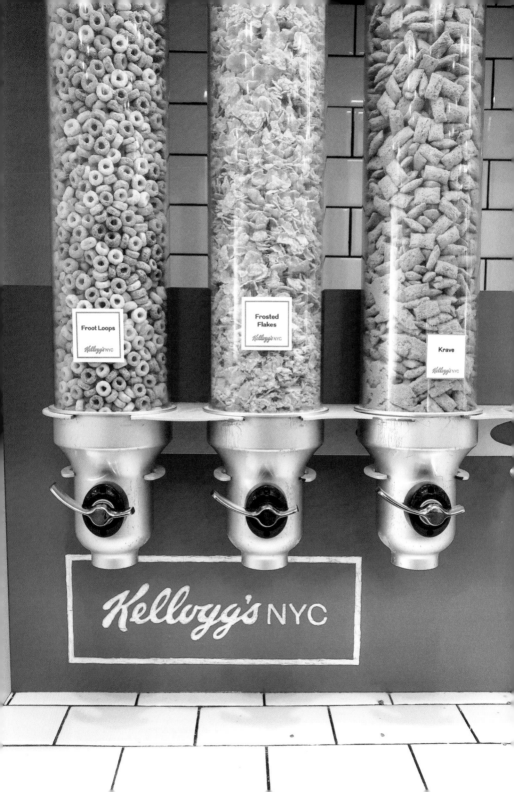

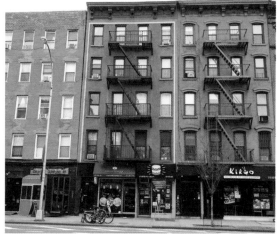

Clockwise from left:
#MediterraneanBreakfast at @Local92NYC (East Village, Manhattan)
#JapaneseMarket at @Sunrise_Mart (East Village, Manhattan)
#ColorfulHouses (East Village, Manhattan)
#HomeDecor at @JohnDerianCompany (East Village, Manhattan)
Opposite Page:
#CerealBowl at @KellogsNYC (Union Square, Manhattan)

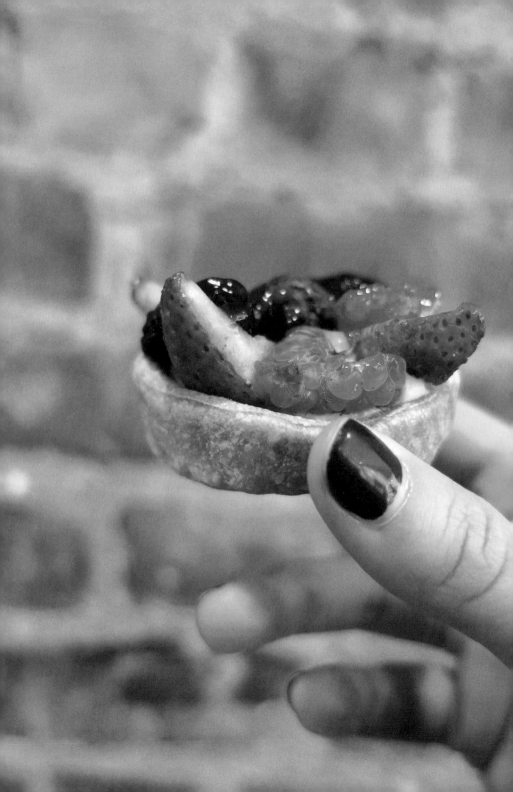

Clockwise from left:
#OutdoorPatio at @Extra_Fancy (Williamsburg, Brooklyn)
#MosaicStyle (Upper East Side, Manhattan)
#VintageShop at @ShopTheBreak (Greenpoint, Brooklyn)
#PinkisEverywhere (West Village, Manhattan)
Opposite Page:
#MiniTart at @FrenchyCoffeeNYC (East Harlem, Manhattan)

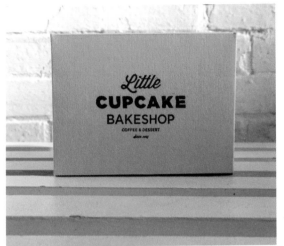

Clockwise from left:
#CupcakeLove at the @LittleCupcakeBakeShop (Nolita, Manhattan)
#FrenchDistrict (Chelsea, Manhattan)
#BeetHummusToast at @CitizensOfChelsea (Chelsea, Manhattan)
#IceCream and #SpeakeasyBar at @TheUESNYC (Upper East Side, Manhattan)
Opposite Page:
#UrbanJungle at @MyCityPlants (Long Island City, Queens)

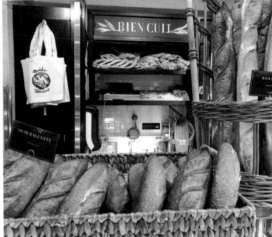

Clockwise from left:
#EssentialOils at @RadicleHerbShop (Boerum Hill, Brooklyn)
#BeigeOnBeige (Chelsea, Manhattan)
#FreshBread at @BienCuitNYC (Midtown East, Manhattan)
#Sportswear at @Bandier (Flatiron District, Manhattan)
Opposite Page:
#HomeDecor at @UrbanOutfitters (Upper East Side, Manhattan)

Clockwise from left:
#ParisianCafe at @CafePauletteBK (Fort Greene, Brooklyn)
#SpringColors at @FortGreenePark (Fort Greene, Brooklyn)
#Cappuccino at @GorillaCoffee (Park Slope, Brooklyn)
#VintageVan (East Village, Manhattan)
Opposite Page:
#Communitygarden "Los Amigos" (Alphabet City, Manhattan)

Clockwise from left:

#CrispyRice at @RubysCafe (Nolita, Manhattan)

#Stationery at the @SeaportMuseum (Seaport District, Manhattan)

#OutdoorDrinking at @TableGreenNYC (Financial District, Manhattan)

#PinkDoor (Greenpoint, Brooklyn)

Opposite Page:

#DontPostThat by @JojoAnavim (Long Island City, Queens)

Clockwise from left:
#FeelingBeautiful thanks to @QueenAndreaOne (Greenpoint, Brooklyn)
#CheapVintage at @BeaconsCloset (Williamsburg, Brooklyn)
#LocalBookstore at @BookCulture (Long Island City, Queens)
#Pasta and #Burrata at @RosemarysNYC (West Village, Manhattan)
Opposite Page:
#BrooklynStoop (Cobble Hill, Brooklyn)

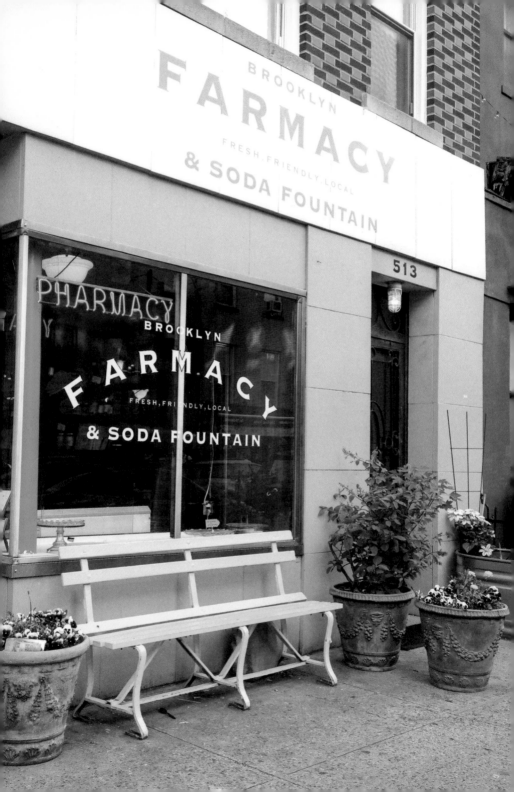

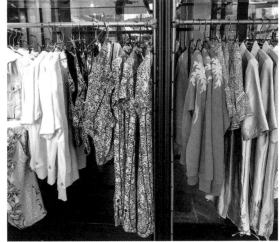

Clockwise from left:

#Espresso at @EastOneCoffee (Carroll Gardens, Brooklyn)

#StackingRings at @WeSeeStarsJewelry (Greenpoint, Brooklyn)

#SpringFashion at @Scotch_Official (Seaport District, Manhattan)

#DriedFlowers at @FlowersByYasmine (Financial District, Manhattan)

Opposite Page:

#IceCream at @BrooklynFarmacy (Carroll Gardens, Brooklyn)

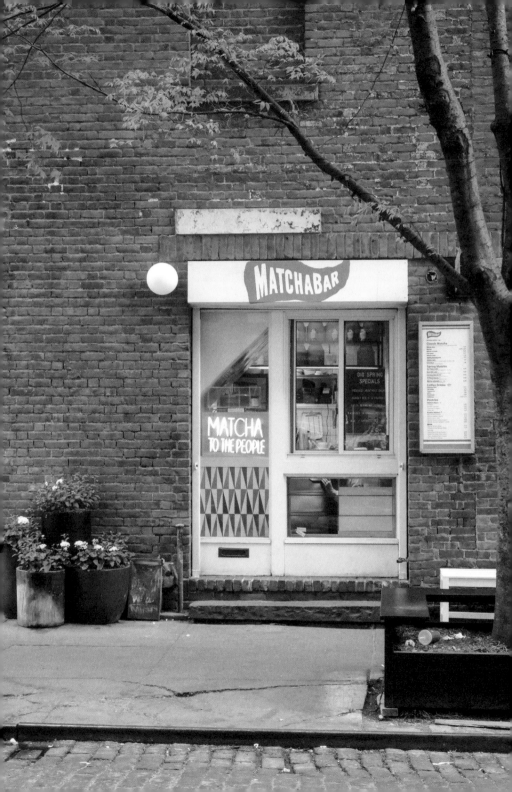

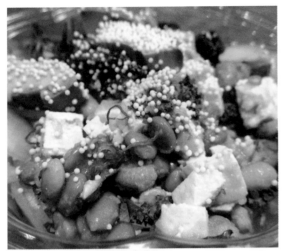
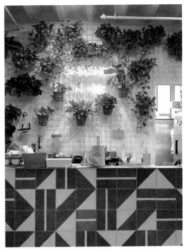

Clockwise from left:
#PokeTime at @MomenTeaOfficial (Chelsea, Manhattan)
#AvocadoLove at @Avocaderia (Sunset Park, Brooklyn)
#CactusGarden at @RoseHipFloral (Greenpoint, Brooklyn)
#CreativeLittleGarden by @GrowNYC (Alphabet City, Manhattan)
Opposite Page:
#MatchaLatte at @MatchaBar (Soho, Manhattan)

Clockwise from left:
#CoffeeAndPlants at @Homecoming (Greenpoint, Brooklyn)
#PublicPlace to chill (Union Square, Manhattan)
#Poke at @PokeZestBKNY (Greenpoint, Brooklyn)
#LocalProduce by @FultonStallMarket (Seaport District, Manhattan)
Opposite Page:
#ActiveWear at @TorySport (Flatiron District, Manhattan)

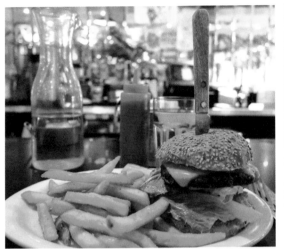

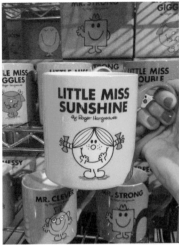

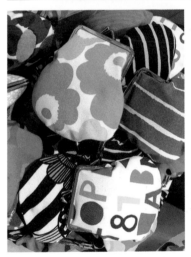

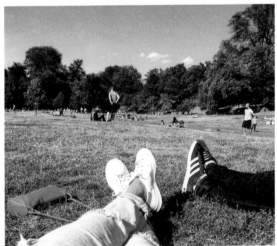

Clockwise from left:
#VeganCheeseBurger at @ChampsDiner (Bushwick, Brooklyn)
#GiftIdeas at @MemeAntenna (Williamsburg, Brooklyn)
#DolceVita in @Prospect_Park (Park Slope, Brooklyn)
#Coinpurse at @Marimekko (Flatiron District, Manhattan)
Opposite Page:
#RainbowCakes at @FlourShop (Soho, Manhattan)

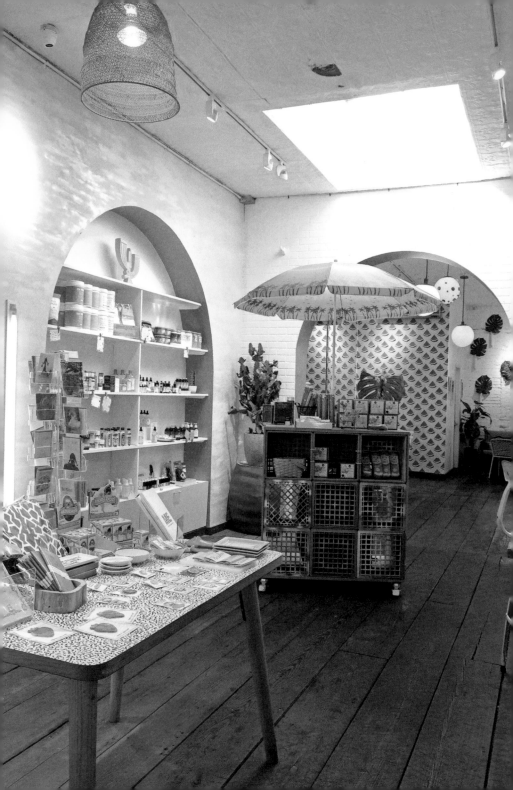

Clockwise from left:

#RaspberryCroissant at @SuperMoonBakeHouse (Lower East Side, Manhattan)

#GiftShopping at @Papyrus (Soho, Manhattan)

#ItalianFood at @Diviera_Drive_NYC (Williamsburg, Brooklyn)

#MediterraneanFood at @EatAtNoon (Financial District, Manhattan)

Opposite Page:

#SmoothieBar at @GrassRootsJuicery (Williamsburg, Brooklyn)

Clockwise from left:
#Cocktails and #Tacos at @CowGirlSeaHorse (Seaport District, Manhattan)
#RiceBalls at @HanamizukiCafe (Chelsea, Manhattan)
#LocalBoutique at @TreeHouseBrooklyn (Williamsburg, Brooklyn)
#RowOfHouses (Greenpoint, Brooklyn)
Opposite Page:
#Coffee or #Beer at @LittleCanal (Lower East Side, Manhattan)

Clockwise from left:
#ManiPedi at @Ph7Nail (Williamsburg, Brooklyn)
#ColdBrew at @CafeineHarlem (West Harlem, Manhattan)
#Breakfast at @BakeriBrooklyn (Williamsburg, Brooklyn)
#BubbleTea at @BarPaTea (Nolita, Manhattan)
Opposite Page:
#PeterPanCollar at @CosStores (Financial District, Manhattan)

Clockwise from left:
#ConceptStore at @ThisIsStory (Chelsea, Manhattan)
#JuiceFeast at @JoeAndTheJuice (Soho, Manhattan)
#Mural at the @PaniniShoppe (Williamsburg, Brooklyn)
#IvyWall (Gowanus, Brooklyn)
Opposite Page:
#Plantbased mexican lunch at @JaJaJaNYC (Lower East Side, Manhattan)

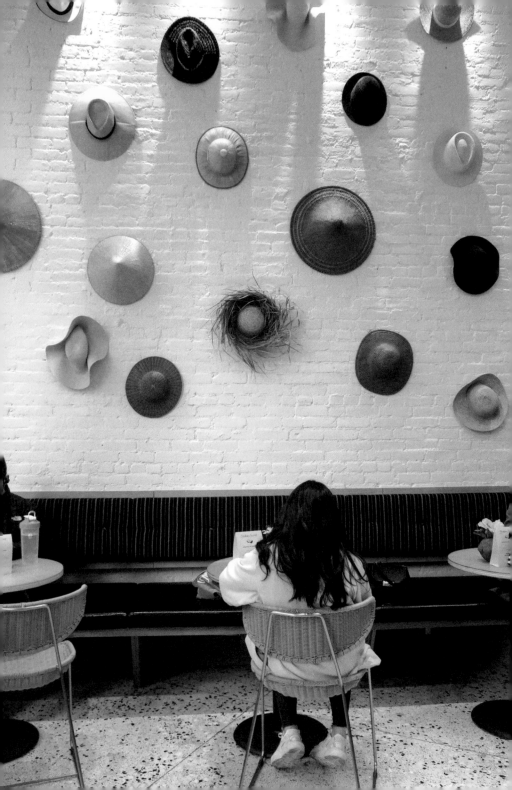

Clockwise from left:
#WineBar at @BlkMtnBK (Carroll Gardens,Brooklyn)
#FallsInTheAir (Noho, Manhattan)
#FlowerShop @BeetleBug_Style (East Village, Manhattan)
#DogWalker Wannabe (Cobble Hill, Brooklyn)
Opposite Page:
#CoconutYogurt at @BrokenCoconut (Soho, Manhattan)

Clockwise from left:

#Planters (Williamsburg, Brooklyn)

#CleanFood at @BlakeLaneNYC (Upper East Side, Manhattan)

#CleanBeauty at @CredoBeauty (Nolita, Manhattan)

#Strawberries by @KateSpadeNY (Soho, Manhattan)

Opposite Page:

#TobysBrooklyn at @ClubMonaco (Flatiron District, Manhattan)

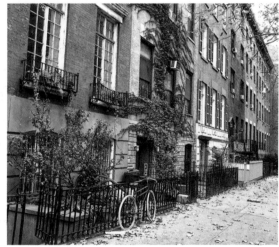

Clockwise from left:
#QuinoaBowl at @Loosierouge (Williamsburg, Brooklyn)
#HeartPendants at @Bulletin.Co (Nolita, Manhattan)
#Facades (East Village, Manhattan)
#ColorPens at @MujiUSA (Midtown West, Manhattan)
Opposite Page:
@Blue_Q #handcream at @SoapCherie (Williamsburg, Brooklyn)

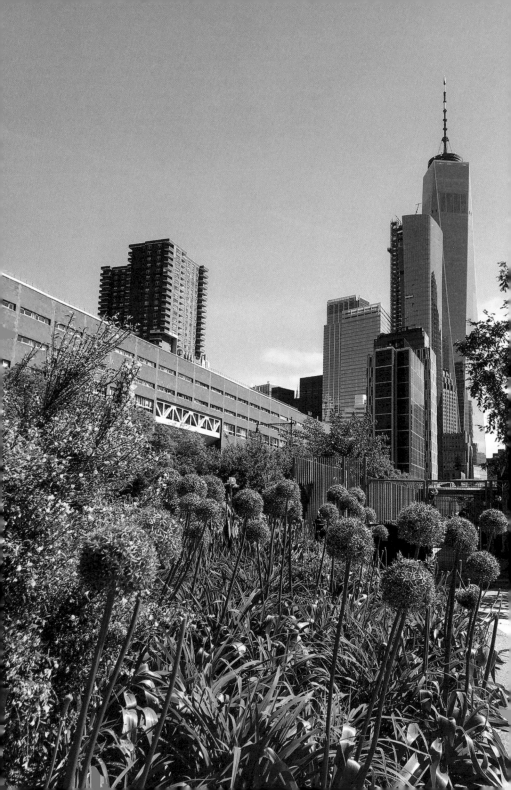

Clockwise from left:
#Directions (Bushwick, Brooklyn)
#Nineties Shopping at @SparkPretty (East Village, Manhattan)
#CuteHouses (West Village, Manhattan)
#GrilledVeggies at @DigInn (Soho, Manhattan)
Opposite Page:
#ParkWithAView (Tribeca, Manhattan)

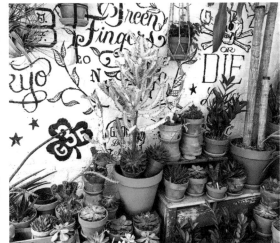

Clockwise from left:

#DreamHouse (Gramercy, Manhattan)

#SpiralStaircase at @BarneysNY (Chelsea, Manhattan)

#Succulents at @GreenFingersMarket (Lower East Side, Manhattan)

#FrenchLiterature at @McNallyJackson (Soho, Manhattan)

Opposite Page:

#CauliflowerBowl at @Lighthouse_Outpost (Nolita, Manhattan)

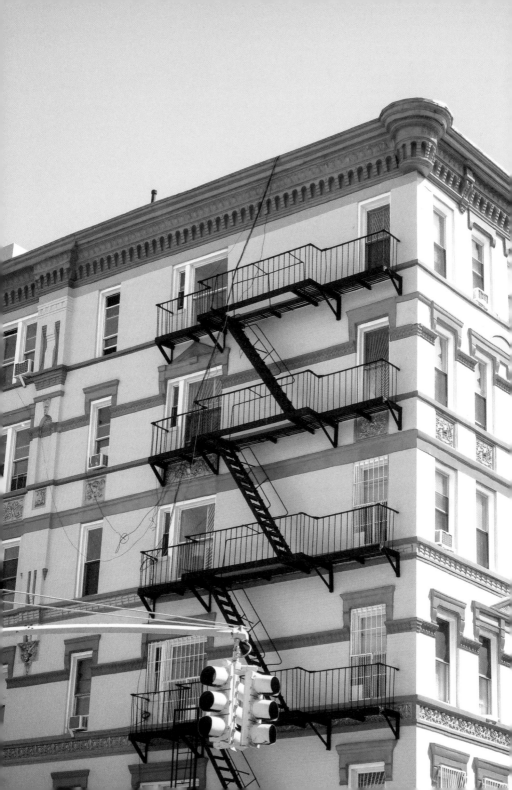

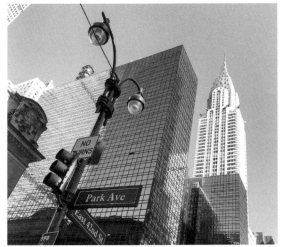
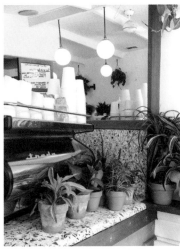
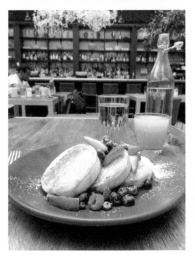

Clockwise from left:
#ChryslerBuilding from Park Avenue (Midtown East, Manhattan)
#Latte and #HibiscusDonut at @ElReyNYC (Lower East Side, Manhattan)
#NothingButTrouble by @BaronVonFancy (Tribeca, Manhattan)
#RicottaPancakes at @TheNomoSoho (Soho, Manhattan)
Opposite Page:
@FavoriteBuilding (Alphabet City, Manhattan)

Clockwise from left:
#ButterAndSage Pasta at @JacksWifeFreda (Soho, Manhattan)
#HomeDecor at @WanderlustreDesign (Carroll Gardens, Brooklyn)
#ThisIsWinter (Alphabet City, Manhattan)
#Gelato by @Gelateria_Gentile_NY (Williamsburg, Brooklyn)
Opposite Page:
#Taqueria at @Tacombi (Nolita, Manhattan)

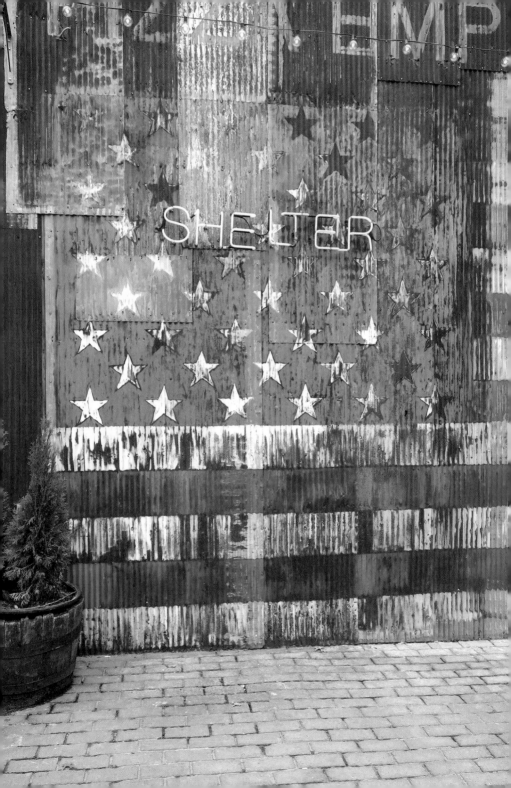

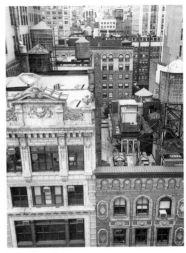
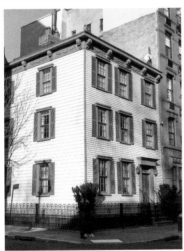
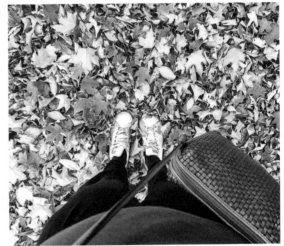

Clockwise from left:
#Bookstore and #Cafe at @HousingWorksBKS (Soho, Manhattan)
#FromWhereIStand view at @HyattHS (Herald Square, Manhattan)
#FallisEverywhere at @CentralParkNYC (Upper East Side, Manhattan)
#CountryHouse style (Greenwich Village, Manhattan)
Opposite Page:
#SaturdayBrunch at @ShelterPizza (Williamsburg, Brooklyn)

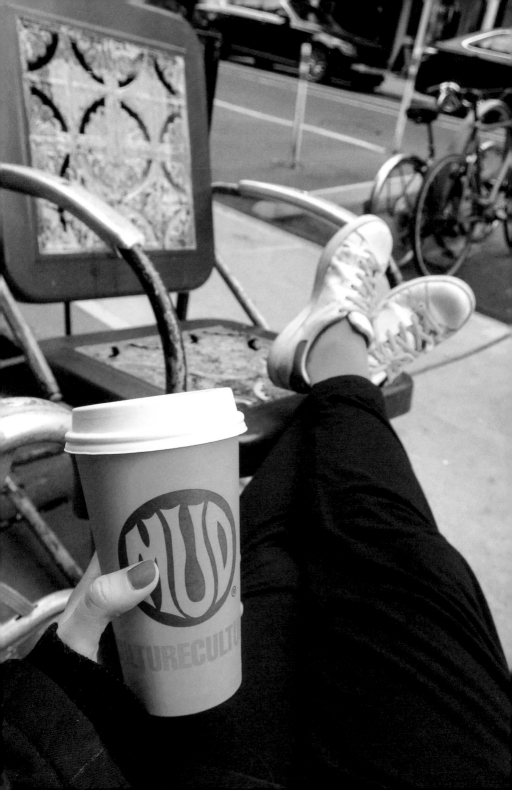

Clockwise from left:
Post #SnowStorm situation (Park Slope, Brooklyn)
#FarmersMarket by @DownToEarthMkts (Park Slope, Brooklyn)
#PumpkinSeason at @UnionMarket (Cobble Hill, Brooklyn)
#WinterWeather (Soho, Manhattan)
Opposite Page:
#NeighborhoodCoffeeShop at @MudCoffeeNYC (East Village, Manhattan)

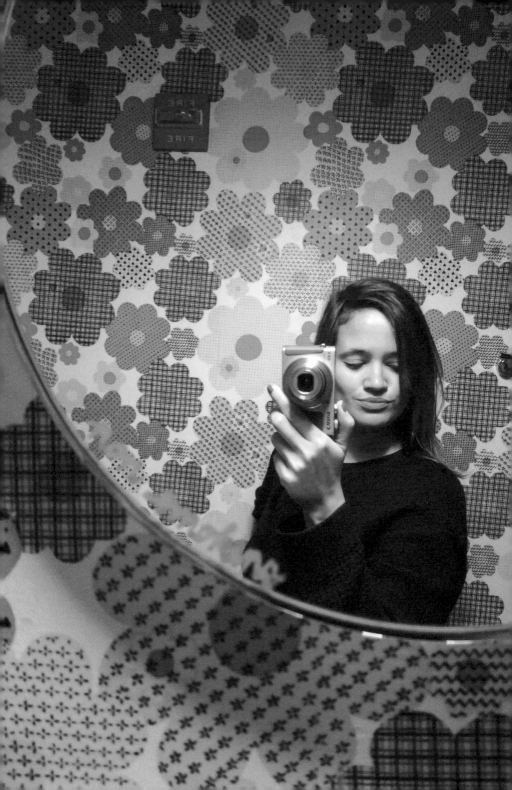

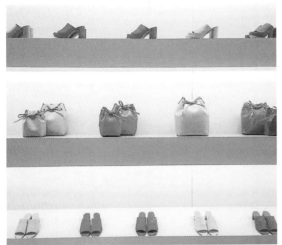

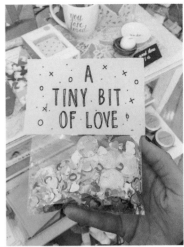

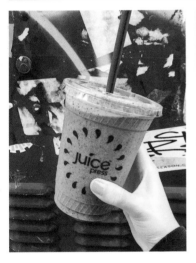

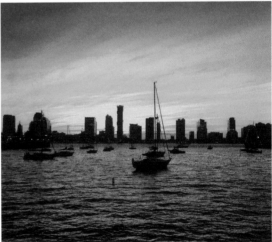

Clockwise from left:
#PinkLove at @MansurGavriel (Soho, Manhattan)
#Confetti at @PinkOlive (Park Slope, Brooklyn)
#Sunset at Pier 25 at @HudsonRiverPark (Tribeca, Manhattan)
#Smoothie at @JuicePress (Tribeca, Manhattan)
Opposite Page:
#FlowerWallpaper at @TheStandard (East Village, Manhattan)

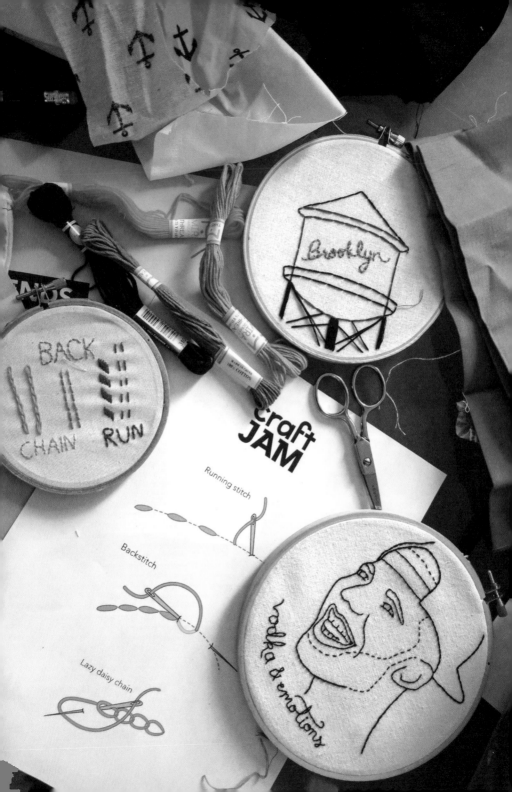

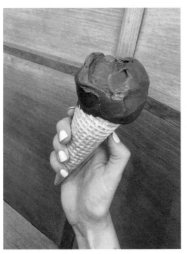
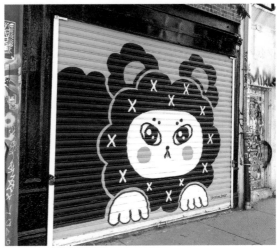

Clockwise from left:
#CoolKidsStuff at @AnmeShop (East Village, Manhattan)
#SidewalkArt by #HHNY (Greenwich Village, Manhattan)
#KawaiiArt by @Harlow_Bear (Nolita, Manhattan)
#BlackSesameIceCream at @VanLeeuwenIceCream (Seaport District, Manhattan)
Opposite Page:
#EmbroideryClass at @CraftJam.Co (Union Square, Manhattan)

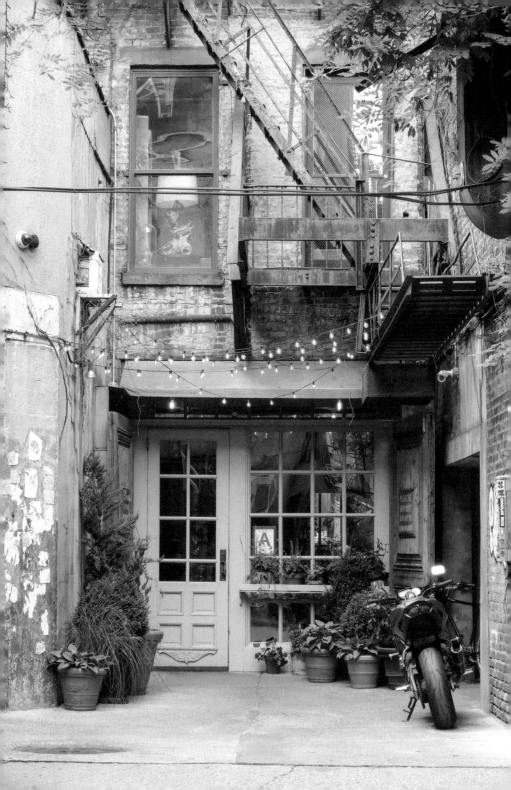

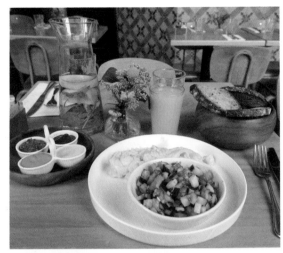

Clockwise from left:
#IsraeliBreakfast at @ReunioNYC (Williamsburg, Brooklyn)
#SaltedChocolate ice cream at @MorgensternsNYC (Lower East Side, Manhattan)
#MiniGarden (Greenpoint, Brooklyn)
#ThinkDifferent by @UncuttArt (Lower East Side, Manhattan)
Opposite Page:
#HiddenGem at @FreemansRestaurant (Lower East Side, Manhattan)

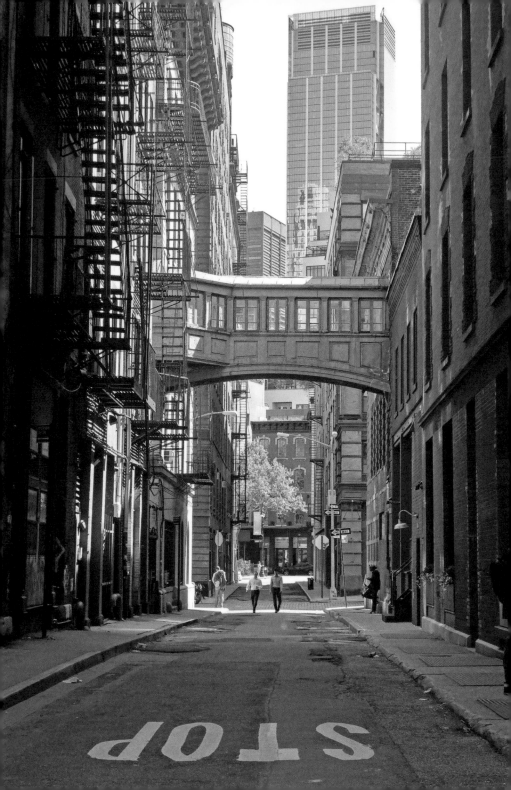

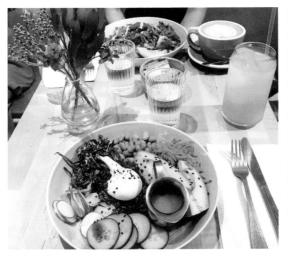

Clockwise from left:
#GreenBowl at @Banter_NYC (Soho, Manhattan)
#SummerDrinks at @LavenderLakeBrooklyn (Gowanus, Brooklyn)
#BeerOnTap at @UpNorthBK (Bushwick, Brooklyn)
#VintageFurniture at @CopperAndPlaid (Greenpoint, Brooklyn)
Opposite Page:
#StapleStreet (Tribeca, Manhattan)

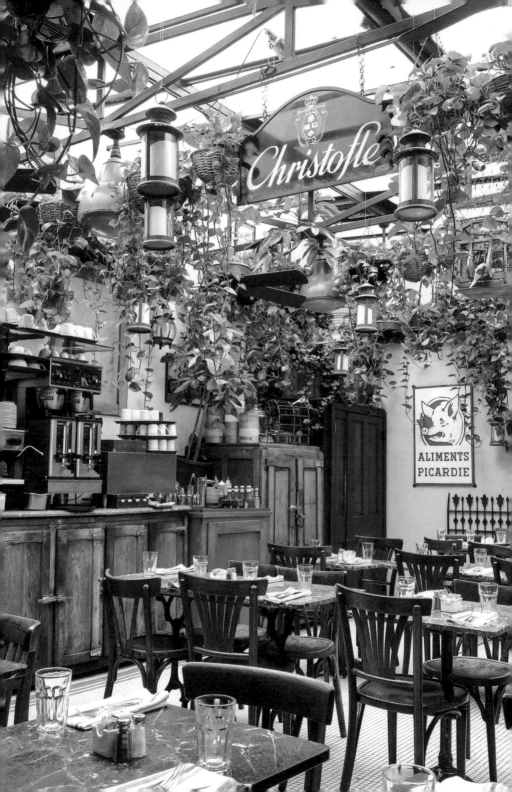

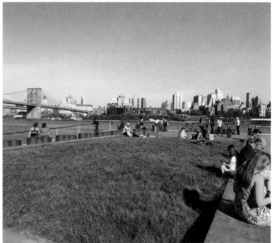

Clockwise from left:
#EveningWalk at McCarrenPark (Greenpoint,Brooklyn)
#Macarons at @LadureeUS (Soho, Manhattan)
#Sunbath at Pier 15 (Seaport District, Manhattan)
#CookingClass at @HomeCookingNY (Soho, Manhattan)
Opposite Page:
#IndoorPatio at @JulietteBKNY (Williamsburg, Brooklyn)

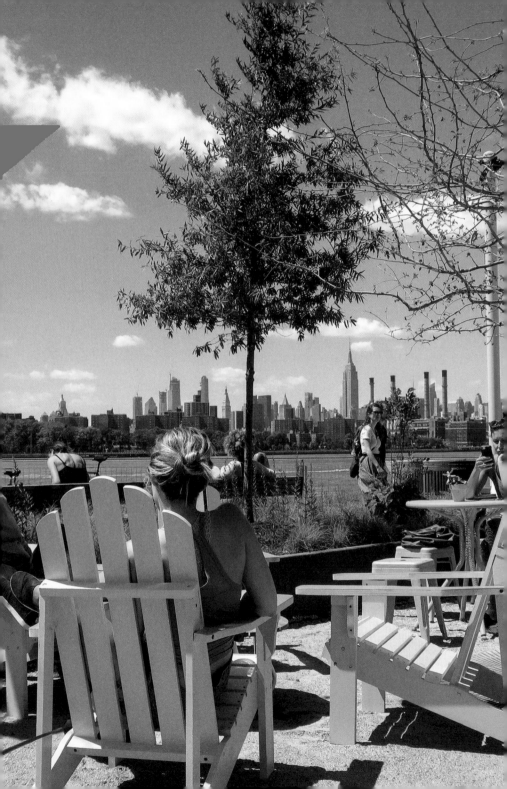

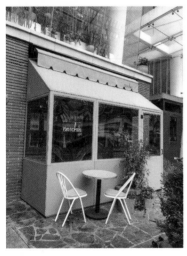
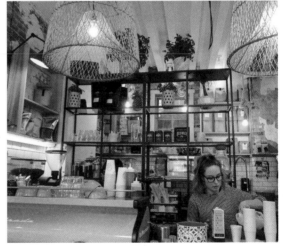

Clockwise from left:
#SkyBlue Building at @NYStudioFactory (Bushwick, Brooklyn)
#HappyHour at @JueLanClub (Chelsea, Manhattan)
#CaffeineFix at @HutchAndWaldo (Upper East Side, Manhattan)
#FarmToTable Dining at @Narcissa (East Village, Manhattan)
Opposite Page:
#Tacos with a view at @HeyTacocina (Williamsburg, Brooklyn)

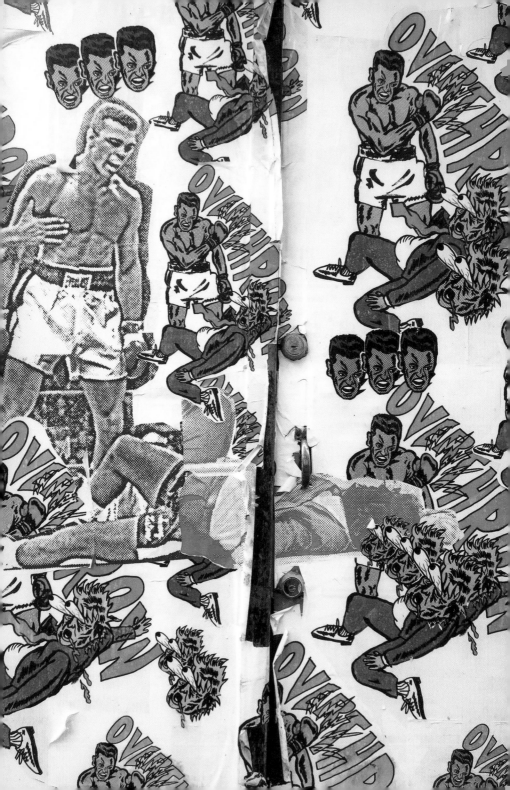

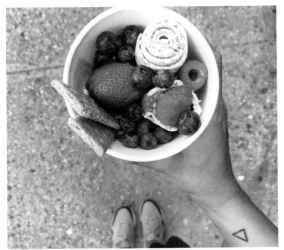
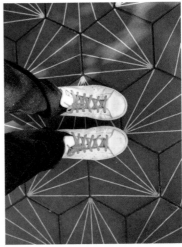
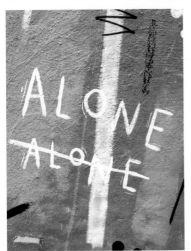
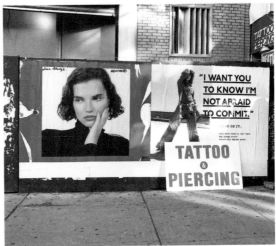

Clockwise from left:
#RolledIceCream at @10BelowIceCream (East Village, Manhattan)
#IHavethisThingWithFloors at @BabyBrasa (West Village, Manhattan)
#SidewalkSign (East Village, Manhattan)
#LeaveMeAlone by @TerryUrbanArt (Nolita, Manhattan)
Opposite Page:
#BoxingClass at @OverThrowNewYork (Noho, Manhattan)

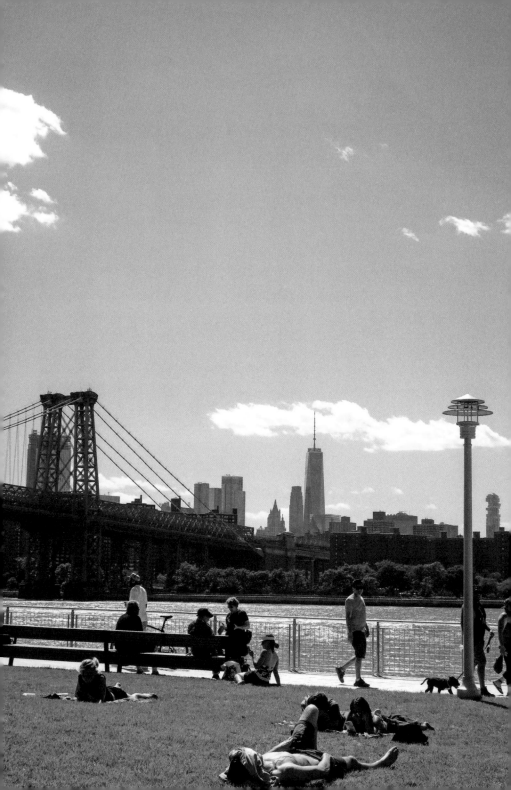

Clockwise from left:
#FallInTheCity at the @HighlineNYC (Meatpacking District, Manhattan)
#IcedCoffee at AP Coffee (Bushwick, Brooklyn)
#IvyHouse (Gramercy, Manhattan)
#PeaceInTheCity along the East River (Alphabet City, Manhattan)
Opposite Page:
#ChillTime at @DominoPark (Williamsburg, Brooklyn)

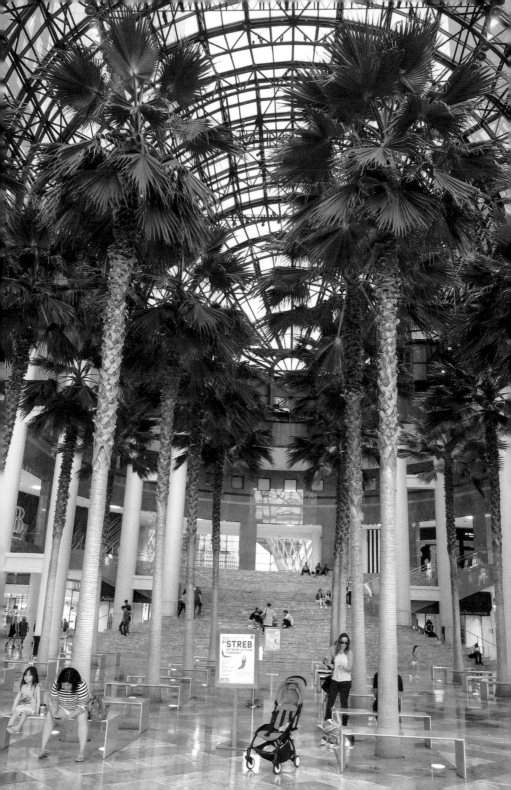

Clockwise from left:
#CheeseClass at @MurraysCheeseBar (Greenwich Village, Manhattan)
#ShadowPlay at @Apple store (Soho, Manhattan)
#Breakfast at @BubbysPieco (Tribeca, Manhattan)
#Drinks and #ComedyShow at @UnionHallNY (Park Slope, Brooklyn)
Opposite Page:
#ShoppingMall at @BrookfieldPLNY (Financial District, Manhattan)

Clockwise from left:
#QuickLunch at @TheBoweryMarket (East Village, Manhattan)
#CuteFashion at @LouAndGreyFlatiron (Flatiron District, Manhattan)
#AvocadoToast at #GatherParkSlope (Park Slope, Brooklyn)
#MoodOfTheDay (Soho, Manhattan)
Opposite Page:
#MicroBrews at @TheTradesManBar (Bushwick, Brooklyn)

Acknowledgements

Zack, thank you for stopping every five steps on every walk in the past five years, so I could take the perfect shot. Without your patience and love this book would have never happened.

Mom, even though you hate travelling, thank you for your unconditional support for my adventures across the world. Your pride means everything.

Everybody at Racine and Lannoo, thank you for believing in my project and for helping me make my biggest dream come true.

Vali, thank you for your priceless support and friendship in this adventure.

Much love to: Vanessa, Geoffrey, Lou, Margot, Laet, Carole, Pam, Audrey, Flo, Véro, all my dear friends from Brussels, Rachel, Stefanie, Cindy, Talie, Anne, Marine, Marion, Julie, Kim, Enora, Benjamin, Gaëlle, Alix, Hervé, Granny, the Bird, GJ, la Team Paillettes, la Team SIBP, la Team Club Med and everybody else I love very much.

All photographies: © Aurélie Hagen
Layout: Aurélie Hagen, Alexandra Jean, Véronique Lux
Cover: Alexandra Jean
Cartes: Véronique Lux
Photo-engraving: Véronique Lux
Logo The Lazy Frenchie: Alexia Roux

This book is published by Éditions Racine.
Éditions Racine is part of the Lannoo Publishing Group.

If you have any questions or comments about the material in this book, please do not hesitate to contact our editorial team: michelle.poskin@racine.be

© Éditions Racine, 2018
Tour et Taxis, Entrepôt royal
86C, Avenue du Port, BP 104A · B - 1000 Brussels

www.racine.be
Register for our newsletter to receive information regularly on our publications and activities.

D/2018/6852/15
Legal deposit: August 2018
ISBN 978-2-39025-054-8